Frank Blum

Digital Interactive Installations

Frank Blum

Digital Interactive Installations

Programming interactive installations using the software package Max/MSP/Jitter

VDM Verlag Dr. Müller

Copyright © 2007 VDM Verlag Dr. Müller e. K. and licensors
All rights reserved. Saarbrücken 2007
Contact: info@vdm-verlag.de
Cover image: www.purestockx.com
Publisher: VDM Verlag Dr. Müller e. K., Dudweiler Landstr. 125 a, 66123 Saarbrücken, Germany
Produced by: Lightning Source Inc., La Vergne, Tennessee/USA
 Lightning Source UK Ltd., Milton Keynes, UK

Copyright © 2007 VDM Verlag Dr. Müller e. K. und Lizenzgeber
Alle Rechte vorbehalten. Saarbrücken 2007
Kontakt: info@vdm-verlag.de
Coverbild: www.purestockx.com
Verlag: VDM Verlag Dr. Müller e. K., Dudweiler Landstr. 125 a, 66123 Saarbrücken, Deutschland
Herstellung: Lightning Source Inc., La Vergne, Tennessee/USA
 Lightning Source UK Ltd., Milton Keynes, UK

ISBN: 978-3-8364-1298-8

Scientia Sine Arte Nihil Est
Ars Sine Scientia Nihil Est

Jean Vignot, 1392

There are no facts, only interpretations.

Friedrich W. Nietzsche, 1886

I want to give special thanks to:

Mr. Prof. Dr. rer. nat. Stefan M. Grünvogel
for his stimulating impulses and creative considerations,
as well as his constant affable motivation during this work;

The Dartington College of Arts
Thanks to the Dean of Information and Learning Christopher Pressler &
the Director of International Development Roger Sell
for making my research at the College possible.
Also many thanks to all other very helpful staff especially in the library,
and to the students for their creative advice,
as well as for practically supporting the work process;

David Cuartielles
for his kind invitation to take part in the Electrolobby
of this year's Ars Electronica Festival;

Carsten Kluth & Mirjam Bregenzer
for their cordial encouragement in my work,
as well as numerous valuable pieces of advice while going
through all ups and downs during the past four years;

Old and new friends, for being there,
as well as for their creative impulses and enthusiastic help
during the time researching and writing this thesis;
Andreas Witzel, Peter Altendorf, Carolina Ciuccio, Uta Baldauf, Doris Valtiner, Heather
Keir-Cross, Travis Kirton and many unnamed others;

My biggest thanks go to
my parents and my sister
without their kind support and affection
this work would not have been possible in this way.

Contents

List of Abbreviations

3D	Three dimensional
ANSI	American National Standards Institute
API	Application programming interface
AR	Augmented Reality
BSD	Berkeley Software Distribution
CAN	Controller Area Network
CAVE	Cave Automatic Virtual Environment
CNMAT	Center for New Music and Audio Technologies
DIY	Do it yourself
DMX	Digital MultipleX (DMX512)
DV	Digital Video
e.g.	for example (exempli gratia)
FFT	Fast Fourier Transformation
GEM	Graphics Environment for Multimedia
GUI	Graphical User Interface
i.e.	it is (id est)
ibid.	in the same place (ibidem)
id.	the same (idem)
IDE	Integrated Development Environment
IEEE	Institute of Electrical and Electronics Engineers
IR	Infrared

JTAG Joint Test Action Group

Motion JPEG Motion Joint Photographic Experts Group
MSP Max Signal Processing

OpenGL Open Graphics Library

PD Pure Data
PDA Personal Digital Assistant

QuickTime QuickTime is a multimedia framework devel-
 oped by Apple Computer

RAM Random Access Memory
RFID Radio Frequency Identification
RS232 RETMA Standard 232

SDK Software Development Kit
SVGA Super Video Graphics Array

TCP Transmission Control Protocol

UDP User Datagram Protocol
USB Universal Serial Bus

VDIG Video Digitizer
VJ Video Jockey

XGA eXtended Graphics Array

ZKM Zentrum für Kunst und Medientechnologie Karl-
 sruhe

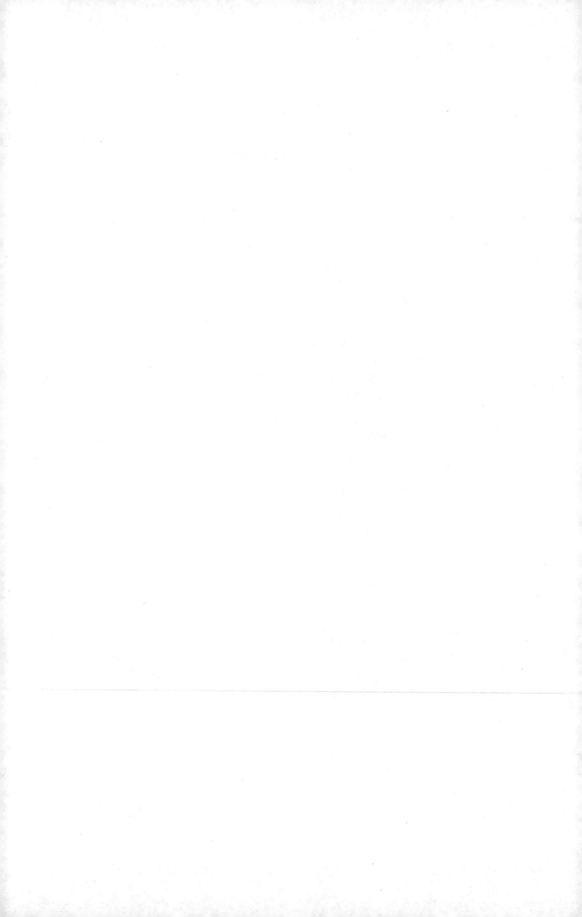

<div align="right">

1

</div>

Introduction

The arts have always been influenced by new evolving technologies. A certain aesthetic turning point was brought about by the silent 'algorithmic revolution' we have not hardly noticed, as the curators of the Centre of Art and Media (ZKM) in Karlsruhe, Germany, propose with their current exhibition. At present, barely any part of social life is not influenced by these decision-making processes (algorithms) habitually executed by our computer devices. The radical changes this revolution causes for all of us are incalculable. However, we should not forget that algorithms, a well-defined set of technical instructions with a finite number of rules designed to solve a specific problem, have been incorporated as a creative instrument in the work of Albrecht Dürer and other artists since the late middle ages. The strict application of algorithms in art ultimately led to works explicitly integrating the recipient into the creative process, eventually culminating in the new media arts. Today's art practices transform observers into users.

Emerging with the changing paradigm is a new type of creator of cultural artefacts. This has been accompanied now for more than two decades by a fruitful collaborative atmosphere between the formerly strictly separated traditions of art and science. More often than not artists like such as the pioneers Christa Sommerer, Laurent Mignonneau, and Jeffrey Shaw are at the same time scientific researchers found in institutional laboratories as heads of larger teams which include programmers, engineers and scientists of various different disciplines. They develop new hard- and software technologies themselves. All in all this development places not only an inestimable number of creative tools in the hands of the artist, but a highly dynamic and hybrid field that forms new

areas like telepresence art, biocybernetic art, robotics, Net art, space art, experiments in nanotechnology, artificial or A-life art, creating virtual agents and avatars, datamining, mixed realities and database- supported art, which all explore the technologies of tomorrow.

Not long ago, artists sought to explore software coding as the foundation of their expression and as a 'material' with specific properties. Like Max/MSP and others, new alternative programming environments based on a graphical interface concept facilitate bridging the gap between art and technology, and bring the artists back more control over the creative process. In particular, Max's main strengths lie in a more intuitive programming approach, its real-time multimedia capabilities and the insertion of interactivity. However, not only artists want to make use of interactivity. Designers and engineers increasingly will also be confronted in their daily practice with immersive interactive media environments due to the wishes of the entertainment market and development of information technologies.

In regard to these ongoing trends in our media culture, the reason for this thesis is the need for research into the specific capabilities of the graphical programming language Max/MSP, and its extension for image processing called Jitter, as a programming environment for multimedia-based digital interactive installations. The paper consists of two parts: The first part deals with the question what the so-called *Cyber Arts* are, primarily focusing on interactive installations. Therefore, at first in Section 2.1 on page 5, it tries to provide a theoretical framework and defintion of its key concepts *interactivity* and *interface design* in full awareness of the exceedingly complex material and constantly shifting positions. A further survey into the scientific debate of these terms would go beyond the scope of the paper. Secondly it looks at outstanding examples of interactive installation art's most recent representative forms and 'narratives' in Section 2.4 on page 10, here also keeping in mind that it can only sketch a very small picture of present arts practice. The following chapter 3 on page 18 is concerned with the basic concepts lying behind Max's programming environment, its options for extensibility with hard- and software interfaces in Section 3.3 on page 27, and a comparison to similar languages currently used in Section 3.4 on page 31.

The second part documents the practical realisation of a multimedia-based interactive installation using the software package Max/MSP/Jitter in Chapter 4 on page 35. It is the outcome of a four month research exchange in conjunction with the Digital Media Centre at Dartington College of Arts in Devon, England. The project makes extensive use of Max's and Jitter's main features like interactivity, its real-time 3D-graphics, and video processing capabilities. Section 4.1 on page 36 gives a background about the ideas and intentions that were the foundation for the final form of the installation, and Section 4.2 on page 40 explains the concept that was leading the realisation phase.

Next, Section 4.2 on page 41 describes all the software parts that were programmed with Max. In the end, a summary of user feedback, and a personal reflection is given. Finally, Section 5 on page 55 concludes the paper.

Part I.

Cyber Arts

The highest demand made on an artist is this:
that he be true to nature, that he study her, imitate her,
and produce something that resembles her phenomena.

Johann Wolfgang von Goethe

Without electricity, there can be no art.

Num June Paik

2

Recent Development of Digital Interactive Art

This thesis begins with a brief overview about the latest scientific and practical research approaches to define the key terms of digital art: interactivity and interface. Afterwards, different possible viewpoints defining distinctive models of interaction in installations give us a formal background for an orientation when looking at concrete examples. This thesis is not meant to incorporate the whole broad and hybrid range of new media art practices. However, it tries to articulate recent main shapes and forms of digital interactive installation and software art in the beginning of the 21st century.

2.1. Interactivity

The essence of interactivity is a field hardly anyone oversees not to mention is able to clearly describe. When we try to define 'Digital Interactivity' we are confronted with a very broad term and an outrageously complex subject matter. Espen Aarseth[1] therefore suggests:

> [A]ttempts to clarify what interactivity means should start by acknowledging that the term's meaning is constantly shifting and probably without descriptive power and then try to argue why we need it, in spite of this.

Obviously, it is important to shed light on its conceptions, because understanding interactivity can help designers create more meaningful interactions and it is therefore the

[1] AARSETH (2003), p.426.

basis for research into digital interactive art.

As a multi-disciplinary key term, interactivity has an intense research tradition of decades. However, scholarly definitions regarding interactivity are 'scattered and incoherent'. Most attempts to define the term put focus either on criteria in which context interactive media are used, on its range, technology or on the perception of the user. But it seems a comprehensive clarification has to integrate all these dimensions. An attempt from Spiro Kiousis[2] to form a more cohesive theoretical framework leads to this tentative definition:

> Interactivity can be defined as the degree to which a communication technology can create a mediated environment in which participants can communicate (one-to-one, one-to-many, and many-to-many), both synchronously and asynchronously, and participate in reciprocal message exchanges (third-order dependency). With regard to human users, it additionally refers to their ability to perceive the experience as a simulation of interpersonal communication and increase their awareness of telepresence.

Here, it is noteworthy Kiousis' definition incorporates interactivity as both: 'a media and psychological variable'.[3]

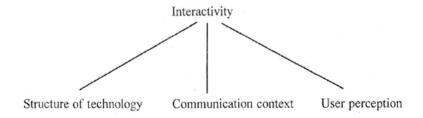

Figure 2.1.: Conceptualization of Interactivity with its major dimensions (According to Kiousis[4])

However, Russell Richards poses his legitimate critique that the definition above has also a weak point, because the focus lying 'on the users perception of the interactivity itself ignores the motivation for being with the package in the first place'.[5] He stresses that practitioners need to think about the *Positioning* of the user:

> [...] their motivations within specific types of media environments and always with regards to the dynamic of generation through the engagement with concepts that can be politically challenging, intellectually or emotionally stimulating or simply raising consciousness about a product.[6]

[2]Kiousis (2002), p.372.
[3]Ibid.
[5]Richards (2006), 535.
[6]Ibid.

In this case, Richard's term Positioning means 'that a user is being positioned into differing relationships with content'.[7] Future analyses will surely need to absorb this and further exciting insights into interactivity as a property *and* an activity.

2.2. Interfaces

The visible/tangible/audible part of interactive art is its interface. As ubiquitous surfaces they allow the capture, communication, generation and exchange of data. Christine Paul defines them as 'the place at which independent systems meet and the navigational tool that allows one system to communicate with the other.'[8] Thus, interfaces of digital art communicate the meaning that is inherent in the whole system. However, as a vehicle for interactivity they should be carefully designed, because they decide whether the user becomes an active participant or remains a sceptical observer; they define the '"experience of being" for that system'[9] as well as their viewpoint. Here, we shouldn't omit to give a hint to the more than actual insights of Marshall McLuhan in his book *Understanding Media* from 1964 in which he coined the prophetic phrase 'the medium is the message'.[10]

Moreover, interaction designer and artist Masaki Fujihata points out the importance of distinguishing 'between the role of the interfaces and the function of interactivity.'[11] On one hand, interfaces should 'be transparent'[12] and on the other they should be self-explanatory. We can say they provide the key to interactivity, as words are the components for building sentences, while with Fujihata, we could say 'that interactivity is the field for constructing sentences'[13] underlying a specific grammar. The user better understands interactivity's grammar (how to interact with the artwork) when we design intuitive and transparent interfaces.

However, we must note there is also another option available for interaction designers to create a meaningful interface: 'the strategy of getting the user to look *at* the interface or object of design rather than *through* it.'[14]. This is a lesson we can learn from various digital arts practices. It is especially important to understand when we want the user not to look through the interface like through a window. In contrast, we can design an interface as a mirror in front of them reflecting the user back to her/himself. This thesis'

[7] RICHARDS (2006), 537.
[8] PAUL (2003), p.72.
[9] ROKEBY (1998), p.31.
[10] MCLUHAN (1964), p.9.
[11] FUJIHATA (2001), p.318.
[12] Ibid.
[13] Ibid., p.319.
[14] BOLTER and GROMALA (2003), 56.

project part[15] can be seen as an example for a reflective interface design strategy.

2.3. Categories of Interaction in Digital Art

Peter Weibel, former head of the Ars Electronica Festival and now director of ZKM Karlsruhe since 1999, proposes three digital characteristics that together compose interactivity in art: 'virtuality (the way the information is saved), variability (of the image's object), and viability (as displayed by the behavioral pattern of the image).'[16] At the same time, it is clearly recognizable that newer art theories[17] stress the crucial importance of the context or environment of an installation system 'as a conditioning factor in the communication process'.[18] This correlates with tendencies in scientific research fields of interactivity to take the user's experience into consideration.

From the user point of view Claudia Gianetti categorizes media-assisted forms of interactivity in three models:[19]

Discrete or active systems: although the user can control the content called up, and the sequence in which this occurs, he/she has no influence on the transmitted information, since the management of this information, which demonstrates predictable behavior, is integrated.

Reactive systems: the work's behavior, which is media-assisted and based on feedback structures, results from the direct reaction to external stimuli, for instance user control or altered environmental conditions. Selection methods and recursive events create cognitive situations for the participative user.

Interactive systems: open program structuring, over which the receiver can also act as transmitter. Since the user can influence the procedure and appearance of the work, or even add new information in the case of more complex systems, it is a matter of content-related interactivity. Temporal, spatial, or content-based relations are established between interactor and work.

It is interesting to see how often devices incorporate different levels of each of the previous categories. A cellphone, for instance, may be considered discrete because it is a singular unit, and most users aren't able to change its basic functions and features; it may also be considered intervenient, because it is a device for mediating between

[15]See Section 4 on page 35.

[16]Weibel (1997), 175.

[17]Art theories influenced by the radical constructivism (Maturana/Varela/von Foerster), and the system theory (Luhmann).

[18]Giannetti (2004).

[19]Ibid.

synergetic network devices. Ultimately, the cellphone is an interactive system because it facilitates adding new information, acts as a transmitter / receiver (i.e. talking to someone else) and is part of a very complex system. In addition, it is a functional device for conveying and retrieving information (that can be as simple as the codecs that transform voices from sound to electricity to sound) and that can be given artistic qualities through industrial / interaction design practices.

Concerning behaviour and conciousness, Gianetti[20] summarizes Peter Weibel's distinctions between three models of interactivity as:

synaesthetic: consists of interactivity between various materials and elements, such as image and sound, color and music.

synergetic: takes place between states of energy, as in works that react to changes in their environment.

communicative or kinetic: between different people and between persons and objects.

With all these attempts to give interactive art a clearer profile in mind it should help us to survey the examples described in the next sections.

[20]GIANNETTI (2004).

2.4. Digital Interactive Art

The term 'Digital Art', similar to interactivity, has a rather watery outline. It stands for a broad range of artistic practices from interactive installations to installations with network components to software or purely Internet-based art. Therefore, an attempt to categorize interaction in this hybrid field must again integrate certain viewpoints.

In this thesis we want to focus on new developments of interactive installations, as one important part of contemporary digital art. We follow Christine Paul, Curator of New Media Arts Whitney Museum (New York), who highlights today's main themes or *narratives* as: 'telepresence, artificial life and intelligence, [...] mapping and data visualisation, [...] as well as multi-user- environments incorporating visuals and sounds.'[21] This year's Prix Ars Electronica jury statement[22] confirms Paul's view about interactive installations:

> Although we agree that the interactive arts are still evolving into a huge range of applications, we would like to point out three important streams.
>
> - Firstly, they are heading deeper into basic research related to natural and artificial living systems.
> - Secondly, they are focused on participatory local and global communication systems and their social and political applications.
> - Thirdly, the interactive arts are increasingly engaged with the critical approach concerning the ideological pattern of programming and the relationship between code, language, and behavior. In this context, the interactive arts have also reconnected to their origins in performing arts and environments.

2.4.1. Main Themes in Digital Interactive Art

The following selection consists of recent examples of outstanding art pieces, giving at least an impression of the multiple manifestations of this highly dynamic emerging art culture.

Telepresence

ACCESS[23] is a permanent installation at the ZKM Museum in Karlsruhe, Germany, by French artist Marie Sester,[24] currently based in New York. She first studied architecture

[21]Paul (2002), p.473.
[22]Fujihata et al. (2006), p.103.
[23]Sester (2006b).
[24]Sester (2006a).

in Strasbourg and after her master's degree she started focusing on how architecture and ideology affect our understanding of the world. As a public art installation it combines surveillance technology, a website, and an especially designed combination of robotic spotlight[25] with an accoustic beam system.[26] Anonymous individuals entering the in-

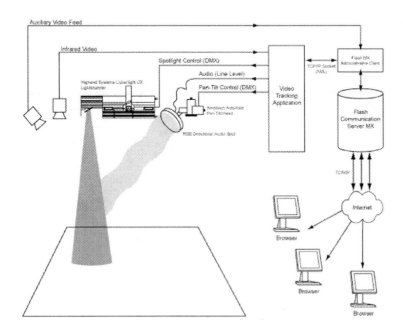

Figure 2.2.: Project ACCESS: Schematic Diagram

stallation space can be tracked by users over an internet connection through a Flash interface showing a real-time video of the installation space, and can then trigger a special tracking software for automatically following these individuals with a spotlight. Additionally, an acoustic beam projects sound with an directional audio spot that only the targets are able to hear clearly. 'The tracked individuals do not know who is tracking them or why they are being tracked, nor are they aware of being the only persons among the public hearing the sound. The web users do not know that their actions trigger sound towards the target.'[27]

The project combines real-time video analysis and motion tracking algorithms using Intel's Computer Vision Libraries (OpenCV), and a custom video tracking application

[25]The auto-tracking robotic spotlight developed for ACCESS is the first of its kind.

[26]Similarly, this acoustic beam (or 'audio spotlight') has never been robotically controlled using computer-vision techniques before.

[27]SESTER (2006b).

together with Microsoft's DirectShow API. The ACCESS client application combines two streams and displays them in the browser using a flash MX plugin.[28] One stream contains the live video feed from a Flash MX Communication Server also handling the queuing of passive vs. active clients. The second stream contains control and feedback data from the tracking application. Altogether, ACCESS' web application provides an almost real-time control and feedback mechanism together with an acceptable streaming video quality; the spotlight is controlled via serial communication employing the DMX protocol usually used for stage lighting. In terms of interactivity here we can see

Figure 2.3.: Project ACCESS: Web Interface with location at Ars Electronica Festival 2003

how internet technologies are applied to enhance the user's awareness of mediated environments (Telepresence);[29] [30] moreover, it creates a certain kind of communicative situation by giving people the possibility to alter other's nearer surrounding area. ACCESS can be described as an interactive system that lets participants influence which individual should be tracked by the spot over great distances, while the system with the surveillance camera gives an immediate visual feedback which effects the lighting and audio projection causes. Its recursive structure also offers a cognitive approach when the user is intervening into the work process.

[28]Flash 7 is required.

[29]KIOUSIS (2002).

[30]Kiousis explains: 'Telepresence has been successfully achieved when the mediated environment is perceived by the user as having similar presence and importance as the physical environment.'

Hypermedia

CAVE The ARSBOX[31] from Ars Electronica Futurelab in Linz, Austria, is an immersive virtual reality environment based on several standard Linux-PCs connected together without loosing performance or other advantages of commercially available million dollar high end systems. For the so-called CAVE, projectors are directed onto four to six walls of a room-sized cube. The walls are made of rear-projection screens and in order to achieve active stereo effects two video projectors with polarized lens have to be used per display; the audience wear stereo glasses to get the immersive impression. In addition, *Palmist*, a special hand-held device[32] equipped with tracker software allows the user to interact with the content on screen. Futurelab's CAVE system is an example of

Figure 2.4.: VRizer– Game Engines on the ARS-BOX.[33]

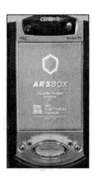

Figure 2.5.: ARSBOX Control Device: The Palmist.

a very strong virtual synergetic 3D experience, sometimes even causing bodily effects like dizziness or head aches. It changes its appearance exactly according to the position and movements of the user's head, or according to interaction through the Palmist interface. Therefore, we have a highly reactive system with real-time reaction to the user's behaviour. The content is a custom-designed environment, hence can't be altered by the user, and ranges from artistic projects over architectural visualisations to industrial applications.

Augmented Reality In the year 2002, Sound artist Gerhard Eckel and his partners in Berlin presented their project *Grenzenlose Freiheit*,[34] which is an interactive sound installation that aims to be a performance, a musical instrument and a game at the same time. Up to three wireless PDA's with simple user interface together control the system

[31]ARS ELECTRONICA FUTURELAB (2006).
[32]A Compaq iPAQ PocketPC based device
[34]RUMORI (2006).

in real-time. The floor plan of the installation space is programmed onto the hand-held;[35] on display the visitor gets information about the position of 24 speakers inside three rooms, chooses where to put the 'sound item'[36] and additionally can influence its characteristics. A wireless network between the PDA's and a host computer enables free mobility of the audience, who are put in charge of creating collectively their own desired sound atmosphere through exploring the possibilities and their spatial configuration with the control devices.

By mixing computer generated sound textures supplementing a 'real world' controlled through a wireless hand-held device, *Grenzenlose Freiheit* provokes a playful acquaintance with the possibilities of the system, the ability to communicate with other participants verbally and through its spatial sound configuration; as a content-related interactive system the user is able to influence the appearance of the work to a certain degree while it aligns real and virtual objects, which poses as a distinctive feature of *Augmented Reality*.

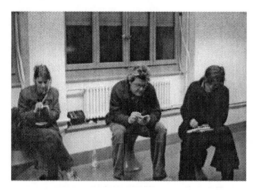

Figure 2.6.: Visitors interacting with the Sound Installation *Grenzenlose Freiheit*

Figure 2.7.: The PDA Interface

A-Live Art

In the recent decades, a new creative arts practice emerged within the tradition. It is called the *Artificial-Live Art*, and seeks to initiate nature's functional structure mainly with the help of computer technology. Pioneers since 1991 are the two collaborating artists Christa Sommerer and Laurent Mignonneau who are now joint heads of a master course in interface culture[37] at the institute of media design, Kunst Universität Linz. In most of their art works they apply 'Artificial Life and Complex Systems principles' using

[35] See Figure 2.7.
[36] RUMORI (2006).
[37] KUNST UNIVERSITÄT LINZ (2006).

'genetic programming to create open-ended systems that can evolve and develop over time through user interaction.'[38] Their latest creation 'Life Writer'[39] consists of an old-

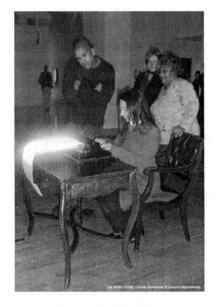

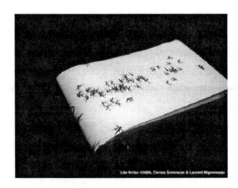

Figure 2.9.: Interacting A-Life creatures on a sheet of paper

Figure 2.8.: *LifeWriter*

style analogue typewriter in combination with a 'normal' sheet of paper as projection screen. Typing results in projected characters floating on the page and transforming into 'small black and white artificial life creatures'. Sommerer and Mignonneau programmed the behaviour and movements of the creatures according to genetic algorithms simulating biological genetics in digital computation, while the text that was typed in functions as their genetic code, i.e. gives (artificial) live to them. Users can interact further; for example, they can 'kill' creatures by pushing them back into the writer, which will crush them and give space for new generations.

The open-ended concept offers not only interaction between people and objects, it lets us observe and influence artificial life-like behaviour of interacting computer generated objects. Coming from a rather young interdisciplinary scientific research field A-Life Art employs its key techniques such as genetic algorithms or cellular automata[40] to mimic or manifest the properties of complex living systems. This approach sounds futuristic, but as Mitchell Whitelaw[41] states, these kinds of works often try to open up a debate on the increasing technologization of living matter in which we are all required to participate

[38]Rumori (2006).
[39]Ibid.
[40]As used in the project, see description in Section 4.2.6 on page 48
[41]Whitelaw (2004).

more and more.

Software Art

Software provides the basis on which meaning and content are constructed in almost all of the electronic arts. A rapidly increasing number of artists explore software as a medium. Artist Casey Reas expresses its key characteristics as: 'dynamic form, gesture, behavior, simulation, self-organization, and adaptation.'[42] Alternative programming environments like Flash, vvvv, [43] Processing, [44] or OpenFrameWorks, [45] [46] excite a new generation of artists seeking to realize their creative ideas through writing software code.

The 'KHRONOS PROJECTOR'[47] seeks to explore new ways of interaction with pre-recorded movie content by touching a deformable projection screen. This received an Honorary Mention[48] at this year's Ars Electronica Festival. It uses a screen made of elastic fabric that is scanned 'using infrared light and a dedicated Vision Chip' [49] in order to compute a 'temporal-pressure' map (see 2.10). Researcher/Artist Alvaro Cassinelli working at Ishikawa-Namiki-Komuro Lab, University of Tokyo, programmed a 'spatio-temporal fusion algorithm' in C++ using OpenGL for computing the dynamic blended high-resolution image in real-time. A simplified demo version[50] of its key technique is realised with the software Processing using a Java applet accepting mouse or touch screen input.

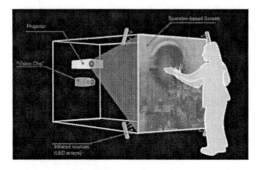

Figure 2.10.: *KHRONOS PROJECTOR* schematic diagram[51]

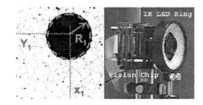

Figure 2.11.: Deformation Pattern produced by the Tracking Camera and Vision Chip using on-axis IR sources

[42] STOCKER and SCHÖPF (2003), p.175.
[43] See description in Section 3.4.2 on page 32
[44] PROCESSING (2006).
[45] LIEBERMAN (2006b).
[46] LIEBERMAN (2006a).
[47] CASSINELLI (2006a).
[48] FUJIHATA et al. (2006), p.126.
[49] ISHIKAWA NAMI KOMURO LABORATORY (2006).
[50] CASSINELLI (2006b).

Opening up a window to new reactive ways of kinetically perceiving movie data, 'Khronos Projector' employs an interesting human-computer interface and is exceptionally intuitive in its usage. Participants read and write to the system simultaneously and are immediately exploring its specific 'interaction grammar'. Certainly, this method bears a multitude of experimentation possibilities other than its present utilisation, even in a simpler form with touch screen or flash light. It can show us what huge potential is slumbering in programming software as a form of artistic expression.

The general precept of any product is
that simple things should be easy,
and hard things should be possible.

Alan Kay

We shape our tools and thereafter our tools shape us.

Marshall McLuhan, *Understanding Media, 1964*

3

Max/MSP/Jitter

3.1. Max History

In the beginning of 1986, *Max* was developed at the Institute de Recherche et Coordination Acoustique/Musique (IRCAM), Paris. Max was originally designed from principal author Miller Puckette to control IRCAM's *4X* synthesizer. From there it grew into a versatile graphical programming language for real-time control of MIDI devices. In 1991 David Zicarelli released with Opcode Systems a commercially available version of Max. At this time, it was a basic set of over 150 MIDI, control, user interface and timing objects.

With the increasing development of computer technology it was possible to directly address the audio hardware of computers and therefore use Max as a synthesizer/sampler. The extension *MSP* is a collection of objects set on top of Max's programming environment, covering all the basic elements of synthesis, sampling, and signal processing.

For several years now *Jitter* has been developed as a Max extension to manipulate video, 3D graphics and other data sets in real-time. The main aspect of this package is that 'Jitter abstracts all data as multidimensional matrices, so objects that process images can also process audio, volumetric data, 3d vertices, or any numerical information'. [1]

Ultimately, the package *Max/MSP/Jitter* is a graphical programming environment for multimedia purposes which, in comparison to abstract coding languages, has an intuitive ease of use, due to its orientation on flow diagrams. Another prominent strength of

[1] CYCLING 74' (2006).

Dipl. Ing. (Fh) Frank Blum

this software concept is insertion of interactivity as described in the following sections and the project documentation.[2]

[2]See Section 4.2 on page 41

3.2. Main Technical Aspects

These sections describe Max/MSP/Jitter's main concepts, followed by important basic principles for the programming practice. Section 3.2.6 on page 24 introduces possibilities to extend functionality with the 'common' programming languages JavaScript or Java. The chapter aims to provide an introduction into the programming technique used with Max and later serves as a background for the project description.[3]

3.2.1. Programming Concept

Like many other high-level languages Max incorporates aspects of object-oriented programming techniques. Modular programming, for example, constructs complex programs through combining many smaller modules. If we can make sure that a module works in and of itself it is a lot easier to locate problems when a program grows larger and larger. This strategy enables us to solve even highly complex tasks by breaking them down into manageable smaller parts. However, these parts again can be further divided into specialized objects, that are 'nested' within other objects.

The one benefit of combining smaller modules is that these components can be reused in another context. A so called library or collection contains a group of objects with descriptive names which can be adopted from other people and situations. Altogether, this technique makes programming with Max very fast and furthermore, these collections of objects, shared by other Max programmers, are available at numerous Internet sites.

Max's objects communicate between each other by sending and receiving messages. How the object works, that is, how the actual process occurs inside a completed object, becomes secondary when it is clear to the programmer what information is received, and what the object will do to that information. The process is purposely hidden, because there is no need to know the more complex details behind the object in order to use it meaningfully. That is why all internal elements that process an incoming message, the internal workings of an object, are encapsulated within.

Another philosophy that is inherent in the programming concept of Max involves some attributes from so-called Fourth-Generation-Languages (4GLs). Here the aim is to enable the programmer to focus more on the task the computer has to do, rather than how the computer can do it. A 4GL environment has a specific purpose which, in Max's case is to enable the processing of mutimedia data and allow for the building of specific functions or complete applications, while simultaneously providing packages of well-defined tools. This is complemented by an intuitive interface that allows the programmer to manipulate data through a set of objects represented by sensible screen graphics, avoiding

[3]See section 4 on page 35.

much of the time-consuming testing and debugging of abstract software coding.

Usually, programs are designed with flow charts and the blocks represent code that will be written. However, Max's strength is its more intuitive approach: it resembles flow charts and the code in the blocks is already written and compiled. The advantage is that this kind of program code is easier to read, and to understand the task, it's intended to do. However, we must note that what is gained in increased productivity is always sacrificed in flexibility.

Max is written in C language which actually interprets icons[4] as functions written and compiled in this procedural language. To manoeuvre around the problem that users cannot access the C code, and therefore cannot do something Max does not offer by default, C programmers are able to write their own customized so-called *externals* (External object); this can be used like any other internal Max object. This may also be one possible way to speed up complex processes in a Max program, since C code runs faster than Max itself.

3.2.2. Max Objects

Basic elements of graphical programming with the package Max/MSP/Jitter are the standard objects,[5] and many more externals from third party developers. Every Object can receive messages from other objects, from the computer keyboard and mouse, or from MIDI instruments and related devices. Messages are sent between them through lines we can draw using the mouse, connecting the output of one object with the input of another. A program written in Max looks similar to the wiring system that was used to control analogue synthesizers and therefore it is often referred to as a *patch*. Because one patch can contain several other *subpatches* the terms 'patch' or 'program' are naming an entire collection of objects or subpatches.

With a palette on top of the screen we can choose from one of the standard objects. They are represented by icons and by clicking one, we can drag and place it (by clicking again) inside the patcher window at the desired location. The palette we can only see while we are in *edit mode,* which is used for programming the patch, while the *run mode* is used for running the application. To switch between edit mode and run mode we can click either on the lock icon in the left upper corner, or we can hold down the command key and click anywhere (except objects and lines) inside the window.

Basically, we have to choose between three kinds of boxes: *Object boxes, Message boxes*, and *Comment boxes*. The Object boxes, which we can recognize by the double lines on their top and bottom, *do something* and the name we type into the box describes

[4]The graphical representations of objects the viewer can see on the screen.
[5]Max offers 200, and MSP adds about 200 more objects for audio processing, while Jitter has 140 objects for matrix and video/image processing.

its function. Message boxes, which have only single lines, send information to objects and the Comment boxes with their dotted lines just display text on the screen without affecting the program. Eventually, the key questions for programming with Max are: 'What kind of action takes place in each box?' and 'What type of information is expected in each box?'

3.2.3. Messages

Incoming messages trigger the process inside an object. After computing the result it sends the data to all the objects that are connected to its *outlet* (small black lines at the bottom of the box), or in case there aren't any further objects connected, the program searches for the next process to begin. We can initialise some parameters, e.g. variables, by entering them directly into the object box as *arguments*, but these we can overwrite with any new data we allow to enter through its specific *inlets*(at the top of the box) while running the application. Generally, inlets are used for the data that is meant to be processed and outlets for passing the data that has been processed to other objects.

Coming with the newer Jitter software there is another possibility to set such initial values or constants, because its objects (and a few Max/MSP objects) can have a great number of arguments which define their behaviour. Through typing the @-symbol into a Jitter object followed by the name of the variable and by one or more arguments, we can set *attributes*; this can be done in any order we like, which is a great help. A list of possible arguments for each Max/MSP/Jitter object is specified in their reference manuals.

We can pass messages from one object to another while they control objects or transport data. Only *messages* are sent or received of which Max understands the following types:

Numbers: Max understands either integer numbers or decimal numbers.

Words: Here, words are called *symbols*. There is a great number of Max objects, that understand words as *control messages*.[6]

Lists: A list begins always with a number and consists of two or more numbers or symbols separated by spaces.

Bangs: A bang is a special message that means 'do it!'

In general, any combination of data mentioned above is also possible.

[6]Messages that define *how* the object operates.

3.2.4. Programming Rules

At least one other aspect needs to be mentioned when we look at Max's basic structure: it executes only one step at a time and proceeds from the right to the left (which means objects to the right of other objects will be processed first). Also, when involving an object with several inlets, Max expects to receive data in the right-to-left order, whereas the data coming into the leftmost inlet usually triggers an action. The same principle applies to objects when sending messages. Furthermore, a single outlet sends data to multiple inlets from right-to-left (if perfectly aligned vertically in the bottom-to-top order). If a message triggers another object, that object will send its message(s) before anything else is done. Considering these rules we are able to figure out exactly how a patcher functions. Altogether, the positioning of objects, and the relative position of their outlet(s) to other object's inlet(s) decide which step in the process has priority according to the right-to-left rule.

3.2.5. Data Types

As we said earlier, Max was originally designed for the MIDI world. It receives data through its specific MIDI objects and can be processed by them or other objects in any way imaginable, since Max expresses MIDI values as integer numbers. Accordingly, numbers can be generated automatically or interactively on-screen with user interface objects and be transmitted to play music. The MSP and Jitter extensions help us to program interesting correlations between the MIDI, the audio and video domains. For example, it is a basic technique to control video data in real-time, with MIDI data physically controlled by a slider, wheel, or sensor data.

As mentioned at the beginning, Jitter supports any data that can be expressed in columns and rows, such as matrix data used in video and still images, 3D geometry, as well as text, spreadsheet data, particle systems, voxels, or audio. Cycling '74's manual[7] mentions further Jitter features:

> [...] the ability to texture 3D geometry with video streams in real-time, convert audio and video streams directly into geometry data, and render models, NURBS, 2D/3D text, and other common shapes. There is even low level access to geometry data and the majority of the OpenGL API for those who need to be closer to the machine.

A Jitter matrix for a picture or video frame usually has two dimensions, but allows up to 32 matrices, each representing a further set of matrix data of the same size called *plane*. However, this concept allows one to deal with the common video data as follows:

[7] BERNSTEIN and CLAYTON (2006), p.13.

A video frame is stored in a 2D matrix with four planes, each containing the information for alpha, red, green and blue, respectively. The data stored in each cell of a matrix can be any 64- or 32-floating-point number, or any 32-bit integer or 8-bit character. To distinguish these storage types in a data set from others, they need to be declared with an appropriate attribute[8] inside the Jitter object.

3.2.6. Programming JavaScript Externals

In addition to its own scripting technique, Max also offers the use of the core of the object-oriented *JavaScript* language[9] within its environment. Using the *js* object we are able to write an external by using JavaScript as an embedded programming language that in a nutshell allows us to extend Max's abilities. This is helpful for example, when we need to program procedural operations that require recursion or schedule timed events in response to messages. The code is evaluated directly by the computer while running the patch and we can edit the JavaScript code within a basic text editor that pops up with the code as soon as we double-click on the *js* object. Although running inside the patch, the *js* object gives an immediate feedback on how the program will behave and when we save the script, it checks beforehand for syntax errors or misspellings.

3.2.7. Programming Java Externals

Since version 4.5, Max supports writing external objects with the Java programming language. In comparison to externals written in C, Java is cross-platform and brings with it all other amenities, for example memory management and a rich and easier networking API. Besides, we can write and compile code within the Max patch and see the result almost immediately without having to quit and restart, since a Java development environment is integrated. Similar to programming with JavaScript, this is enabled through a proxy external object called *mxj* written in C, that interacts with an instance of the Java virtual machine (JVM) within the Max application, as shown in Figure 3.1 on the facing page.[10] With the inbuilt development environment *mxj quickie* it is even possible to create Java code without leaving Max; this enables immediate source-level access. Consequently, it is very easy to edit new code, extend functionality or quickly fix bugs in existing Java code, while running the patch.

There is a constantly rising number of hardware components designed especially for use within the Max environment. They range from touch-screens, tracking multiple fingers simultaneously, to MIDI and wireless UDP interfaces for sensors, controlling

[8]*float64, float32, long* or *char*
[9]Netscape, Version 1.5.
[10]LA FATA (2004), p.6.

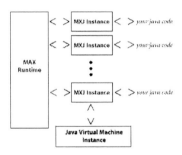

Figure 3.1.: Functioning of the Max Proxy External Object *mxj*

motors, valves, etc., all provided from many commercial and open source developers.[11] Altogether, Max offers various ways for accessing sensor data as a basis for creating meaningful human-computer interaction far beyond mouse and MIDI keyboard control.

3.2.8. Networking with OpenSound Control

Since version 4.6 Max allows the building of reliable networks with computers and other multimedia devices or interfaces via the transport-independent, message-based protocol OpenSound Control[12] (OSC). OSC was developed in 1997 by Matt Wright at the Center for New Music and Audio Technology[13] (CNMAT), where the protocol is completely an open-source project. As a flexible high-level protocol it can also use various low-level protocols, e.g. TCP, or more commonly with UDP network protocol. Max implements OSC with its cross-platform *udpsend* and *udpreceive* externals using UDP protocol, which in turn implements a subset of the OSC protocol, but which are both compatible with the OpenSound Control and OSC-route objects.

OSC itself is implemented in many other software and hardware systems like Java,[14] Flash,[15] SuperCollider,[16] Make Controller Kit[17] and many more. Hence, it offers a very flexible basis for transferring Max's performance data in real-time to and from other soft- and hardware components like musical instruments, controllers or other multimedia applications.

[11]We will give a brief overview in Section 3.3 on page 27.
[12]CNMAT (2006c).
[13]CNMAT (2006b).
[14]MAT (2006).
[15]BENCHUN (2006).
[16]CNMAT (2006d).
[17]CNMAT (2006a).

3.2.9. Documentation

This thesis is not the place where we want to gain in-depth knowledge of the Max package's programming techniques. However, the tutorials on the developer's site are an excellent starting point for learning how to realise one's ideas. Moreover, each object has its own help file containing an example patch, which provides detailed information about its usage, and further, can be used as a basis for our patches, because they are nothing else than editable Max patches themselves.

A further source for advice is the developer's website forum and the community of users standing behind it. We can find a great deal of answers in its archive. Most third-party developers share their code for free to use it in non-commercial applications and therefore it is worth searching on the internet for external objects or patches already doing what we want (or sometimes needing only a small adjustment), before we consider starting programming by hand. Similarly, the developer's website provides many useful links around programming techniques, user experiences and to sites with open-source external objects and example patches.

3.3. Hardware Interfaces for Interactive Installations

3.3.1. Special Use of conventional Devices

The following examples briefly describe the main features of interfaces that aren't developed specifically for interactive installations, but still have the potential for exciting human-computer interaction. This, of course, can't be seen as a completed list of products currently on the market.

Tablet

Tablets are one of the most common human-computer interfaces subsequent to mouse and keyboard. However, they offer interesting possibilities the latter don't. For example, they are very popularly in use for musical instrument interfaces; there is an interview on Cycling '74's web page with Matt Wright[18] from CNMAT about the issue.

A prominent developer of tablets is *WACOM* with its *Intuos3*[19] series. All at the same time this particular tablet sends the pen's position on the board, pressure, and tilt information back to the computer. For Max there exists an external object supporting WACOM boards from Jean-Michel Couturier.[20]

Lemur

A special version of a tablet is *Lemur* from developer Jazzmutant.[21] The advantage of this multi-touch surface is its ability to allow control over objects on a 12 screen with more than one finger at the same time. We can use a palette of configurable graphic objects to design our interface according to the application we want to control. Lemur offers connections via MIDI or its potential successor OSC.[22]

Joystick

As an alternative, joysticks are rather cheap 2-dimensional controllers for our parameters. Moreover, we can let users feel reactions from the system through Force Feedback Joysticks. *V-Joy*,[23] a project realised from artist Edward Müller at University of Art Berlin's Design department, is an application programmed with Max/MSP and Jitter for Vjs who want to control their performance with an interface that has a certain optical presence on stage distinct from control over keyboard or mouse. Signals coming via

[18]Costabile (2006).
[19]WACOM (2006).
[20]Couturier (2006).
[21]Jazzmutant (2006).
[22]Described in Section 3.2.8 on page 25.
[23]Müller (2006).

USB connection are filtered and can be assigned to different preferred functions. This application combines an intuitive interface with basic video manipulation capabilities.

Camera

Very common in interactive installations for controlling events is the use of cameras in all kinds of combinations. Normally, working with a computer we use a digital camera or web cam, but we can also use analogue cameras combined with an interface that digitizes signals in real-time. There exists for Jitter several externals for real-time video processing and tracking like the very strong package softVNS 2,[24] commercially available from artist David Rokeby;[25] soft- and hardware products helping to quickly track positions of users, performers or dancers inside installation environments with high precision. Another widely used possibility is a camera sensitive to low light frequencies to pick up infra-red light (wavelength: 780nm-1mm). In this case, it is useful to put up a filter in front of the lens allowing only the infra-red light to let pass.

[24] ROKEBY (2006b).
[25] ROKEBY (2006a).

3.3.2. Hardware Interfaces for Transducers

Now we take a brief look at more sophisticated technologies for gaining information from outside the computer through sensors, or giving feedback to the environment via actuators, as a common way for designing more natural interactions between installation systems and their environment. For this task already exists a selection of different implements and with some technical experience it is quite easy to build one's own specific device by hand according to the increasing number of DIY manuals documented on the world wide web. Most concepts integrate micro controllers that handle information from nearly any sensors[26] and actuators[27] available on the market. The *serial* object in Max/MSP offers direct access to devices connected to serial ports. The following list mentions only a few exceptional examples of interface systems that work very well with Max's and similar software environments.

Arduino Project

Here, worth pointing out is the open-source project *Arduino*[28] that received an Honorary Mention at Ars Electronica Prix 2006.[29] It offers a relatively affordable physical computing platform based on a simple i/o board (see Figure 3.2) and an IDE that implements the Processing[30]/Wiring[31] language. The board can be used to develop stand-alone interactive objects or in conjunction with software like Max, PD, vvvv, Flash and many others. It can be assembled by hand with an Atmel ATmega8 microcontroller (8KB bootloader) supporting 6 analogue and 13 digital pins; the IDE is also open-source. In the near future Bluetooth boards for wireless data transmission are on the roadmap.

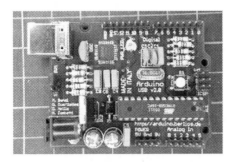

Figure 3.2.: USB Board from the open-source project Arduino

[26]For light, touch, accelerometers, RFID, etc.
[27]Like electrical motors, relays, pneumatic actuators and so on.
[28]Arduino (2006).
[29]Schöpf and Stocker (2006), p.188.
[30]Processing (2006).
[31]Barragn (2006).

Make Controller Kit (Making Things)

This summer Making Things started a new module series: the *MAKE Controller Kit*, consisting of an Atmel AT91SAM7X256 controller board[32] programmable in C, in combination with an application board, is taking over the *Teleo* series. Its high-performance 32-bit sensor interface features Ethernet, USB, OSC, high-current outputs, JTAG, many kinds of motor control (DC, servo, stepper), CAN, RS232 and further possibilities. Similar to the Arduino project, Making Things provides users with details about hardware configurations and programming issues on their website.[33]

Kroonde Gamma

French developer La kitchen manufactures wireless sensor interfaces named the *Kroonde Gamma*[34] system. It supports 16 analogue sensors[35] with a precision of 10 bits per sensor and transmits data over MIDI or UDP with high bandwidth Ethernet (10MB/s). Communication to computers works via three protocols: MIDI, Binary[36] and OSC. La kitchen says its effective range in difficult environments is 30 meters, otherwise in normal conditions up to 90 meters. Depending on the Ethernet transmission frequency[37] it updates all sensors between 9ms and 17ms. The wireless transmission box runs with 9V batteries for about 10 hours, depending on the sensors attached. For Kroonde diverse sensors for a broad range of artistic practices are available from the developer: acceleration sensors, fibre optical flex sensors, force sensors, gyroscopes, Infra-red proximity sensors, mercury sensors of movement, to mention only a few.

[32]Memory: 64KB of RAM, 256KB of Flash memory, and additional 32KB of EEPROM.
[33]MAKE (2006).
[34]LA KITCHEN (2006).
[35]Split into two connectors with eight sensors.
[36]FUDI is a protocol implemented in Pure Data which is described in Section 3.4.1 on the facing page.
[37]Frequencies are 433 Mhz/869 Mhz for Europe, which updates faster than with the 914 Mhz for use in the USA.

3.4. Alternative Programming Concepts

This section deals with the most prominent alternatives to Cycling '74's Max/MSP/Jitter package and their main differences. This is in respect to the highly dynamic market, thus the examples described below are only a small percentage of today's available range of approaches. Especially in this niche of software development, a growing generation of programmers are dedicating themselves to the open-source movement, making it possible to learn collaboratively and share their gained knowledge among internet communities.

3.4.1. PD (Pure Data)

Pd is completely open source Graphical Development Environment, that means it is free downloadable software and has freely accessible source code, in contrast to the commercial product Max/MSP/Jitter. It stems from the same branch as the Max family and is originally developed since 1996 from Miller Puckette, the developer of Max's roots. The fast growing developer community behind it has chosen its main centre at IEM[38] (Institut für Elektronische Musik) in Graz, Austria.

It works on Linux, IRIX, MacOS X, and Win32 operating systems, therefore can be used very flexibly on nearly any old or brand new computer to PocketPC. Like Max, it stems from the audio processing application, it is easily extendible with diverse externals or libraries (collections of externals) and even implements open-GL based 3D graphics with the *GEM* package by Mark Danks.[39] Additionally, we can program externals by ourselves and share them with other programmers.

Figure 3.3.: Pure Data Patch with its basic programming elements

Figure 3.4.: Pure Data main window.

Some Max patches can be imported to PD, but the converse is not possible. Many users in the scene look at PD as the 'grown up version of Max' because of its revised

[38]ZMLNIG (2006).
[39]DANKS (2006).

inner structure, but the disadvantage is that installation and configuration can be more difficult. In some eyes, a slight advantage of Max is its more user-friendly designed GUI and the GUI-objects making the start slightly easier for artists who are not used to the programming principles. All in all, PD is a full potential alternative to Max for people who don't care about a prettier GUI and aren't afraid of a more complicated handling technique, typically to most flexible open-source software at present.

3.4.2. vvvv

Very similar to Max and PD's programming philosophy, *vvvv* from developer Meso, situated in Frankfurt, Germany, focuses on video synthesis, its main feature being the support of hardware accelerated 3D graphics based on DirectX. Thus, a 3D accelerated graphics card is strongly recommended as this restricts vvvv usage to either a Microsoft 2000 or XP platform. For accessing the advanced pixel and vertex shader capabilities a DirectX 9 compatible card is needed. If all these hardware requirements are provided it is theoretically a much faster image and video processing software than Max or PD.

Figure 3.5.: Example Patch in vvvv– moving the mouse over an inlet or outlet shows infos about its functionality

Another speciality of vvvv is handling multiple objects with its technique called *Spreads*, which facilitates programming of complex behaviour for a large group of objects. *Boy-grouping* is another function for seamless multi-projection set-ups using render clusters with client-server network architecture. As with Max and Pd, it supports a very large variety of high- and low level protocols for communicating with other computers or software, e.g. remote management of installations via internet. vvvv seems to be the optimal choice when focusing on very fast video/image processing and not so much on audio applications, although this also is basically possible.

3.4.3. Isadora

In 2004, the graphic programming environment Isadora from Troika Tronix (New York) won an 'Honorary Mention' at the Prix Ars Electronica[40] in Linz. As a modular live performance tool it runs on MacOSX platforms[41] and emphasises real-time video manipulation also supporting hardware accelerated rendering. Over one hundred objects called *actors* can be arranged on a graphical programming interface and when grouped together can also perform as a custom *User Actor*.

Many video processing modules are taken from the FreeFrame[42] plugin system which is a steadily growing open-source project implemented by various other applications, e.g. vvvv. Another very interesting feature is its live video and sound input capabilities used for manipulating pre-recorded video. Like the preceding examples we can extend its functionality with an SDK using C or C++ language. Through MIDI or OSC it communicates with other computers, sensor interfaces or software like Max, Pd and Super Collider, etc. Serial output through computer ports (RS232) is also an option.

Obviously, Isadora is mainly a VJ-tool, though other uses are imaginable. Distinct from 'conventional' fixed programs, it allows the creation of a unique artistic expression through its modular structure, offering almost uncountable combinations of actors. This complexity is not as far reaching as that of Max and others, but brings a certain ease of handling and learning effort.

[40]AEC ARS ELECTRONICA CENTER (2004).
[41]Currently public beta phase for Windows platform.
[42]FREEFRAME (2006).

Part II.

Project Documentation

Imagination is more important than knowledge.
For knowledge is limited, whereas imagination embraces the entire
world, stimulating progress, giving birth to evolution.

Albert Einstein, 1929

The field of vision is comparable, for me, to the terrain of an archaeolog-
ical dig.
To see is to be on guard, to wait for what emerges from the background,
without any name, without any particular interest: what was silent will
speak, what is closed will open and will take on a voice.

Paul Virilio

4

Project: Make a change

Within the last decades, the boundaries between various scientific disciplines began to shift. Boundaries also moved between the roles of artist and designer, engineer and technician. A growing number of dynamic academic departments around the world fulfil the need for research into more intuitive and integrative interfaces. Pioneering this new paradigm is the Massachusetts Institute of Technology's Media Lab, especially its Aesthetics and Computation group headed by eminent professor for Media Arts and Sciences John Maeda.[1] For years now his department's focus has been on applying a method of interconnected development in an unusual range of disciplines including the interplay between programming and art. Peter Weibel claims the post-modern field to be the convergence of 'art as social construction and science as social construction',[2] thus trying to establish the ZKM as an outstanding forum in the world for science, art, politics and finance.

According to this new model of dynamic interrelation, the project part for this thesis takes into account ideas and knowledge from very different scientific research fields. The documentation deals with the questions why the installation exists in this form, which concept is leading the realisation process and how it is actually realised using the programming environment Max/MSP and its extension Jitter. Afterwards, the process is reflected in a summary of user feedback and personal viewpoints.

[1]MIT MEDIA LAB (2006).
[2]WEIBEL (1997), p.174.

4.1. Project Introduction

In contrast to conventional works of art, digital technology can give artists the opportunity to transform visitors from passive viewers into active participants. The interactive behaviour of most works is based on a program that is interpreted by a computer, which realizes the reactions the artist chooses. It is as if he holds up a mirror to the spectators, making them communicate with themselves through the medium. Internationally acclaimed artist, David Rokeby,[3] describes this relationship as follows:

> The medium not only reflects back, but also refracts what it is given; what is returned is ourselves, transformed and processed. To the degree that the technology reflects ourselves back recognizably, it provides us with a self-image, a sense of self. To the degree that the technology transforms our image in the act of reflection, it provides us with a sense of the relation between this self and the experienced world.

In this respect, we follow Fujihata's[4] proposal that 'interactive works use computers to organize events for the emerging self in real-time, as a reflection of our lives, and an aid in finding a reason for our existence.'

We give and we take. Our exchange, as a part and as active participants of this world, is a feedback loop, and it is the core of interaction with our surroundings.[5] The starting point for creating the interactive installation described in the project documentation was, thoughts derived from observing the present patterns of western cultural interaction itself. For us, the leading question in the beginning is: How can we describe and make clear what mainly characterizes these interactions nowadays? It turned out, that it was very useful observing the patterns of interaction under a temporal structural perspective, in order to analyse what our current cultural premise is based on.

It is a commonplace to state that the world has never seen so many changes, primarily due to technological inventions, as in the past century. Meanwhile, the pace at which this progress develops is breathtaking and the common reaction is to accept and automatically adapt to it.In late-modern society, there appears to be only one major paradigm, that underlies all its key processes: the logic of continued need for acceleration.[6] When we look back in history, we can easily perceive, how it has always been the demand for accelerated growth, that encouraged modern western society to transform its existing structures. Of course, this mainly concerns the economical sector. The recent enormous push creating new waves of acceleration, which affect our everyday

[3]Rokeby (1996).
[4]Stocker and Schöpf (2001), p.318.
[5]Haahr (2001).
[6]Rosa (2005).

life, took place around 1989, with the collapse of the soviet union and the victory of turbo-capitalism, accompanied by the digital revolution. In fact, new in late-modern times is the speed of and loss of resistance to how these processes, like the movement of information, money, goods and people, but also ideas and diseases, take place over great distances.

Is there also an acceleration of the subject, the identity or the way of being? Our sense of who we are is almost a function of our relations to space, to time, to our fellow men, to the objects of our environment and also to our own actions and experience. Vice versa, our own actions and relations reflect our identity; it's a relation of interdependence. In social sciences it is well known, that the structure of society correlates with the structure of individuals, thus, social processes of modernisation must have their counterpart in the construction of identities.

Temporal structures have fundamental normative implications. 'How do I want to live?' is the core ethical question, and proceeds directly from the question of: 'How do I want to spend my time?' The time patterns and horizons of society therefore, lie in the centre of ethics. The deepest philosophical explanation for this relation we can find in Martin Heidegger's book 'Being and Time'.[7] Furthermore, sociologist Hartmut Rosa[8] quotes Robert Lauer pointing out the nature of individual and collective existence as having essentially temporal and procedural character:

> The self is process; the temporal dimension is fundamental. To neglect the temporal dimension is to neglect the essence. We shall never understand the human by simply analysing the individual as a stable configuration of traits, qualities, or attitudes.

Actually, the perception of one's temporal experience now becoming dominant in western states, is of privation of time and stress, the need for more time, or having not enough time.[9] This development is paradoxical when we think of the enormous technological advancements and sophisticated organisational planning, directed towards the saving of time in ever increasing quantities. In other words, it appears the more time we save, the less is actually at our disposal. Also, many time-budget studies[10] document the widespread opinion, that we haven't got the time for 'the really important things' in our life: time pressure makes individuals do things they would not choose under other conditions. From the perspective of another planet's intelligent being we must look absurd.

[7]Heidegger (1927).
[8]Rosa (2005).
[9]Wenger (2006).
[10]Ibid.

It is not the thesis' challenge to argue the highly complex causes and consequences accompanying these ongoing cultural changes on either an individual or collective level. Nevertheless, for an understanding of the creative process in this work, we are interested in looking at the appearance of a certain type of identity in late-modern society and its relation to the project by way of modernity: the promise of self and social autonomy.

In late-modern age the situational personal identity is emerging from the classical, which tries to orientate itself on a relatively stable framework and is characterised by a certain direction, which becomes manifest in a life concept and binding future perspective. In contrast, the new form of personal identity is characterised by terms like player or drifter and reacts to the individual's highly dynamic environment with flexibility and attendance to change in all its spheres. Kenneth Gergen describes his way to this new kind of being as follows:

> I am also struggling against my modernist training for constant improvement, advancement, development, and accumulation. Slowly I am learning the pleasures of relinquishing the desire to gain control of all that surrounds me. It is the difference between swimming with deliberation to a point in the ocean - mastering the waves to reach a goal - and floating harmoniously with the unpredictable movements of the waves.[11]

That does not necessarily mean it is a passive style of living- often the opposite is the case. The main difference however, between these ways of being is the fact that the situational identity refuses to create long-term aims in a wider area of contexts and therefore loses its narrative sense and direction of the moving self or life through time. This is understandable in respect to the often unpredictable circumstances of a rapidly changing horizon of life-options, which make it fairly impossible to see the future relevancies. These in turn must therefore be set from oneself as the centre of focus. Rosa describes this state of being: 'Life doesn't move anywhere, it finally steps on one place with a high tempo of changes.'[12]

Obviously, the self-conception cited above is self-contradictory in light of its claim for enhanced control over and (co-)authorship of ones life. Today's accelerated feedback loops become constantly tighter, until they can't work properly. Combined with our cultural trend strongly focusing on consumption and production aspects, it's a most notable reason for concern when we look at the challenges our and future generations are facing. It raises the question, if modernity's aim to establish individual and political autonomy is coming to an end, whether we are loosing control over our actions at

[11] GERGEN (2000), p.150.
[12] ROSA (2005), p.384.

a point in history where our accumulated knowledge and technologies cause highly complex consequences reaching far into the future. We are unable to understand and anticipate these, thus we can not longer take responsibility.

Reflection however, as an essential part of every feedback loop, can place the needed insight and digestion of experiences into experience to put back a sensible meaning back into that cycle. A task that is becoming more difficult in our accelerated culture, as time goes on.[13] In this respect, the main intention of the interactive installation, described on the following pages, is to shift our focus away from acceleration towards reflection. In order to do so it sends the user on a small journey, at first questioning existing patterns, then providing a space that encourages her/him to spend some time on thinking about the issues mentioned above.

It makes sense to describe the different parts of the installation chronologically in their appearance to the visitor. But before that, we look at the concept that leads the process of technical realisation, which also helps to prevent the detail from becoming lost in itself. Most Max programmers point out the importance of having a clear view of their intentions beforehand estimating the feasibility of desired results for saving energy during the realisation phase. However, there is no supreme concept of how to program with Max and many objects and filters invite the exploration and opportunity to play with their various options.

[13] Haahr (2001).

4.2. Main Concept

Before a user enters the installation room alone she/he has got to put her/his own opinion into the system in terms of a very short video statement (one word or two) that will be recorded directly onto the computer hard disk. The question asked is: 'Who runs your world? Who or what is affecting your life the most?' Then she/he will enter a darkened room and find a microphone on a stand four meters in front of a projection screen. This setting serves as the user interface. The room is also equipped with an amplifier and loud speakers[14]. The user should be able to leave the room through a second door for reaching a third room that provides a calm atmosphere for reflecting and discussing the experience or reading some informational material, and tables for putting up ideas or further statements on the issue.

The projected material has a definite chronological order when appearing to the visitor. At first, the statements of all previous users will be played continuously recurring without sound. The program senses the input level of the microphone, therefore serving as a start button triggering a sequence of events eventually reaching a predefined threshold. In the beginning of the sequence the video images transform into 3D-shapes, that change their form depending on the sounds the user generates next to the microphone. While the statements are still playing she/he can hear their original sound and also an audio track of a ticking clockwork. After a period of time this configuration again transforms by fading slowly into the emerging shapes of a cellular automata, until the 3D representation dissolves completely. This process finally ends with a short signal from another audio track playing a hooter sound followed by a 30 second video sequence especially composed for the installation. Afterwards, the user can decide whether she/he wants to have another chance or go to the third room. In the following pages we will have a closer look at the technical methods and programming practice.

[14]See installation sketch Figure A.10 on page g in the appendix.

4.2.1. Concept of the Software Development

The aim of the project is to develop a digital interactive installation using the Max/MSP software and its extension Jitter. We chose the software because its structure allowed us to freely create our own functionality as the ideas surfaced during the work process, instead of adapting to a fixed application varying its optional parameters. For a concept like this[15] there is of course no ready application on the market anyway and it would take us much more time and energy to realise it with conventional programming languages like C or Java. With the help of easy accessible documentation it needs a comparably short time to learn Max's basic structure and principles in order to be able to start programming; thus enabling a non-programmer to solve even complex tasks without needing years of experience.

This project incorporates many of Max/Jitter's capabilities and strengths as described in the previous chapter.[16] Our program is meant to be adjustable to different hardware components and room situations, thus we don't mention any products for running the installation, only outlining its basic hard- and software requirements. For a first orientation, we can have a look at the installation sketches[17] and the hardware scheme.[18]

Referring to the attempts for categorisation of interactive installations in Section 2 on page 5 we can locate this work in the section of systems that enable users to add new information and provide temporal and content-based relations of interaction. The installation also acts as a communicative medium combined with synaesthetic attributes.

4.2.2. Video Recorder

The Recorder patch 4.1 on the next page has a very basic structure that quite adequately serves the needs of our installation. Jitter allows connection of any QuickTime-compatible[19] DV device via the *IEEE 1394 interface*[20] to the computer and records the incoming signal (video and audio) as a QuickTime movie directly to the hard disk using the *jit.qt.grab* object without sending out any matrix output. *Jit.qt.grab* provides an interface to one of QuickTime's components and offers full control over name, destination, dimensions, sound settings, video format and capture quality. We use this object because it is the right tool for storing video in jitter matrices without manipulating the data while recording. For controlling the previously recorded video statement we can start a small video playback on a monitor inside the patch. If we are not happy with the

[15]Previously described in the introduction. See Section 4.1 on page 36.
[16]See Section 3.2 on page 20.
[17]See figures in Section A.2 on page g in the appendix.
[18]See Figure A.9 on page g in the appendix.
[19]APPLE COMPUTER (2006).
[20]Also Firewire or i.Link.

result we can tick a box for overwriting the last clip on the next record.

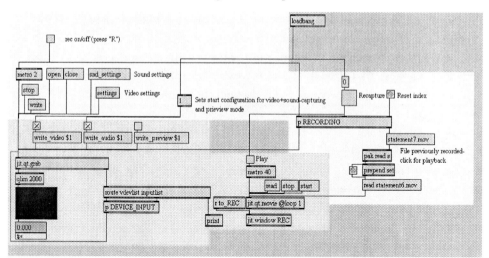

Figure 4.1.: The Recorder main patch

Within the patch we have a 'nested' patch *p RECORDING* which includes a further sub-patch programmed for automatically giving each video a name with increasing indices. It also passes every new index to the video playback subpatch *p READ*[21] for its maximum counter with the help of a *send* object (short: *s*). It sends any type of messages without patch cords to its counterpart: a *receive(r)* object which must possess the same name as its argument. We can place it anywhere we like even, inside other patcher windows.

4.2.3. Main Patch

The core of our installation is the Main Patch.[22] It sends all control messages to the action patches via the *timeline* object. This is a basic concept of Max/MSP, that can be described as a combination of a score and a multi-track sequencer allowing the sending of *event* messages at a desired moment to a so called *action* patch; a patch defined by a track inside the timeline score. We can start the timeline by simply sending a *start* message to the *timeline* object. Additionally, we can relocate to specific points by sending a *locate* message into its inlet, or by using a *search* message that locates to a *marker* event specified in a special *marker* track inside the timeline editor window. The *action* patches themselves can send messages back to the timeline using a *thisTimeline* object (e.g. for timeline commands), or out of one of timeline's outlets with the *tiout* object inside the patch specified by an index. Our *timeline* object has the attribute six,

[21]See Figure A.4 on page e in the appendix.
[22]See Figure in Section 4.2 on the next page.

i.e. it offers six outlets for usage from the action patches. The data stream coming out

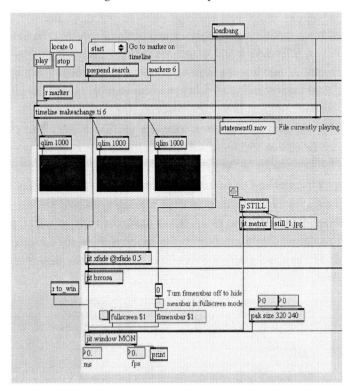

Figure 4.2.: Main Patch

of its first (leftmost) outlet stems from the video playback *action* patch.[23] The Synalizer data[24] comes out of the second, and the game's[25] matrices from third outlet. Each of them are connected to a small *jit.pwindow* for monitoring their content. For saving more calculating capacity a *qlim* object suppresses all frames except one displayed every 1000 ms. We use a *jit.xfade* object for smoothly changing the content of the projection from the synalizer to the game.[26] Further, we have the possibility to adjust the video in its brightness, saturation and contrast. We set the initial parameters to 1.2 (the value 1 means no change), because the result of a pixel addition from *jit.xfade* usually needs an enhancement of the image.

The other parts[27] of the Main Patch are concerned with adjusting the final image by sending control messages to the *jit.window MON* which are then calibrated to the tech-

[23]See Figure 4.7 on page 50.
[24]See Figure 4.5 on page 47.
[25]See Figure 4.6 on page 49.
[26]In this case within a time interval of 16 sec.
[27]See Figure A.3 on page d in the appendix.

nical equipment we use. This lets Jitter find out the coordinates and set the projection screen's parameters automatically. Through pressing the space bar the video will be projected in *fullscreen* mode via the projector and pressing 'Esc' returns to the computer window. A press on 'S' creates a still image of the scene currently projecting for documentation purposes. Altogether, we have a very flexible system that can be adjusted to different equipment incorporating all other parts we want to use for the projection, and automatically controlling them in a single patch.

We can edit the timeline by double clicking the *timeline* object. The graphic editor window pops up as shown in Figure 4.3, and for each *action* patch we add a track, including one for the marker events that can be addressed from patches through the *search* message. We could add other 'ordinary' patches as well, but only action patches, stored in a specific folder,[28] are able to send messages back to the timeline via the *thisTimeline* object. The beginning of the boxes mark their trigger point, whereas they can have different attributes according to the message they are expected to send at the assigned time. Here, we solely use *bang* messages 3.2.3 on page 22 for triggering installation events.

Figure 4.3.: Timeline Editor Window

4.2.4. Sensing the Microphone

This *action patch* decides if a user makes any sounds next to the microphone. It serves as a component waiting for the user to be ready and then starting the experience. The patch continuously computes the mean amplitude of the input signal at an interval of 20 ms. In this case we use the *adc~* object that receives analogue audio signals from channel one converting them into digital signals which are sent from its outlet. The *avg~* computes the average of this incoming signal since it last received a *bang* message. If the amplitude reaches a certain threshold the patch sends a *search* message to the

[28]Inside Max's search path in the *action* folder.

timeline object triggering the sequence beginning with the *Synalizer*. The initial sensitivity is set to level three and becomes less sensitive with increasing number. The level depends amongst others on the sensitivity of the microphone and changes to the signal like an additional amplifier between computer and microphone, and therefore must be adjusted with the final installation setup. The patch stops computing the amplitude when reaching the threshold and starts again when it receives a *bang* message from the *timeline* object in a further sequence cycle.

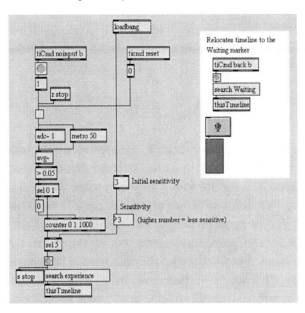

Figure 4.4.: Patch for sensing microphone input

4.2.5. The Synalizer

The *Synalizer 0.6alpha* is an experimental work-in-progress application from Markus Dermietzel,[29] which aims to emulate the author's own subjective, synaesthetic perception, inducing shapes on an 'inner monitor',[30] depending on the tone colour he is hearing. His application analyses sound and transforms it into 3D-shapes in real-time. Besides artistic viewpoints, we choose the Synalizer because it allows us to connect a microphone as our user interface, it offers an easy access to its parameters and has a very clear structure and programming style, enabling us to integrate the patch into the installation system without complications.

[29] DERMIETZEL (2006a).
[30] DERMIETZEL (2006b), pg.36.

The sound from the microphone is routed into a modified FFT-Based *analyzer* external from developer Tristan Jehan,[31] that derives several parameters[32] from the digital signal together representing the tone colour. Synalizer maps these parameters into a Jitter module that connects basic 3D-shapes in a network. Six shapes each created by a *jit.gl.gridshape* object are mixed together, whereas the analysed parameters determine the ratio of mixture. Each parameter is connected to a corresponding basic shape:

Pitch \longrightarrow Plane
Loudness \longrightarrow Sphere
Brightness \longrightarrow Torus
Noisiness \longrightarrow Cylinder
Amplitude \longrightarrow Circle
Sinusoid 1 \longrightarrow Cube

Together, the basic shapes generate one single 3D-shape we mantle with the video statements from the hard disk. In order to correctly render the final shape we need to declare the video stream as a texture with a *drawto* message for the final, as well as for all its basic shapes. This is due to Jitter's concept of OpenGL rendering combining the *jit.gl.render* object and its declared destination as a *drawing context*.[33] Here, several GL objects like our *jit.gl.gridshape* can be used to draw things into this context with a common set of attributes 'that allow them to be positioned in 3D space, colored, and otherwise modified–the *GL group*.'[34] Furthermore, this concept allows multiple renderers, and each of them as well as each *GL group* object to have an independent destination, which can be useful, e.g. if we want to move objects in the *GL group* between different renderers.

However, Synalizer offers several other features for the setup. Inside the main patch, we can adjust gain control of the microphone, the brightness of shape lighting, zooming and rotating the entire scene. 3D shape controllers representing multipliers let us influence the mixture of basic shapes, and there is another controller for calming the scene, when it gets too shaky. In addition, it is possible to control most parameters with a MIDI-controller, namely with MIDI control numbers 0-15. Most of these settings we must adjust to the specific situation, that basically depends on the technical equipment and room situation. After completing the setup or interesting combinations we can store and recall them in a pre-set.

The *timeline* objects trigger the beginning and end of rendering the 3D scene. They

[31] Jehan (2006).
[32] Dermietzel (2006b), pg.44.
[33] Bernstein and Clayton (2006), pg.267.
[34] Ibid., pg.269.

start the *Synalizer* and sensing of the microphone input, trigger *drawto* messages to the renderers and *Gl groups*, and also the output of the frames back to the *timeline* object through the *tiout* object. A *ticmd reset* object sends a *bang* message switching off *Synalizer's* computations and its output while it isn't required. In this document we can't look closer at *Synalizer's* 'inner workings', and therefore must refer to the original author regarding further questions.

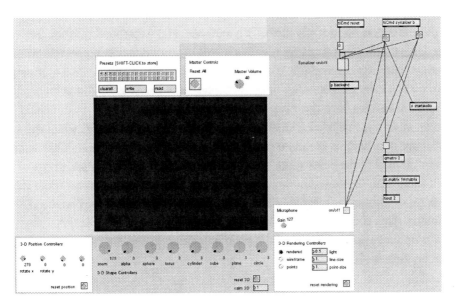

Figure 4.5.: The modified *Synalizer* main patch

4.2.6. The Cellular Automaton

This patch contains a cellular automaton[35] (CA) that receives a single frame from the Synalizer patch.[36] This happens once the timeline sends a *bang* message into *jit.matrix fmmatrix* object's *inlet* 'containing' the actual computed matrix of the Synalizer. This object passes the matrix data, that will be processed with the CA, to the *jit.matrix life* object. The *jit.conway* object computes every next generation (here every 2 ms) of matrix data with the help of a feedback loop. Each cell of the four planes changes its state depending on the state of the cell's neighbours and a specified rule set. The cell's output is set to the value 0 or 255 (dead or alive). A second matrix object following the *jit.conway* object also named *life*, closes the loop and is set to *thru mode*, i.e. it outputs a matrix when it receives another one. In this case, the user has no direct influence on the produced pattern once the automaton starts computing.

We can view the result on a small monitor inside the *action patch*, while the same matrices are sent back to the main patch coming out of *timeline* object's third *outlet*.[37] We can also modify the rules setup how data is processed inside the *jit.conway* object, as well as its size. In this case, we have a rule set that lets cells survive when having 2,3,5,6,7,8 neighbours respectively, and giving birth to new cells if they have 3,6,7 or 8 neighbours. This is differing from Conway's standard game of life rules.[38] Changes to the rules or dimensions of the matrix depend on personal subjective viewpoints and the system performance.

4.2.7. Automatical Recurring Movie Playback

The video playback patch, triggered by the timeline, plays all recorded statements in a row, and after a full cycle automatically starts with the first clip again. It is designed to deal with the files recorded onto hard disk and be able to send the video data to the Synalizer patch. The files are chosen automatically by the *p READ* subpatch every 3 seconds.[39] It receives an integer message from the Recorder patch when a statement is recorded and uses it as its new maximum counter.

When a user speaks into the microphone the noinput patch[40] triggers the sequence with the Synalizer. At this moment, we automatically need to redirect the video data to the renderer and *GL groups* using a *Ggate* object switching the right inlet between two outputs. If we wish we can add an interpolation algorithm, enhance playback quality

[35] GARDNER (1970).
[36] See Figure 4.6 on the facing page.
[37] See Figure 4.2 on page 43.
[38] Ibid., p.120.
[39] See Figure A.4 on page e in the appendix.
[40] See Figure 4.4 on page 45.

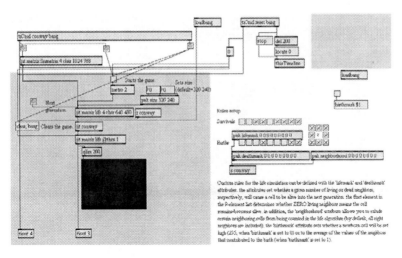

Figure 4.6.: Patch with Cellular Automaton

and resize the texture respectively, which all needs more capacity from the graphic card. Triggering the switch, the fader, and resetting to the patch's original state also controls the timeline via its *tiCmd* objects. In the figure below we let the cords from *tiCmd* objects connect directly to the inlets for an easier comprehension of the data flow.

Cycling '74 recommends the following parameters for movie playback in its tutorials:[41]

- 320x240 frame size

- 15 frames per second

- Video tracks: Photo-JPEG codec, using a medium to high spatial quality setting

- Audio tracks: no compression

However, this is a very rough guideline and we must experiment with settings on each new hardware combination since there is no perfect recipe for getting better results. We must note that Jitter generally decompresses media into an offscreen buffer, therefore normally uses software codecs for playback. Obviously, movie dimension and frame rate are the most significant parameters to enhance Jitter's live performance. For better image quality in movies the developer recommends using the Motion JPEG codec, but this results in much larger files and nor does Jitter use the codec's special hardware support.

[41]Bernstein and Clayton (2006), p.522.

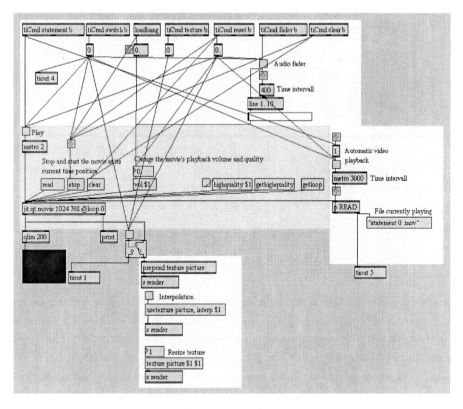

Figure 4.7.: Patch for playback of the video statements

We use another submodule with a very simple structure for presenting the video at the end of the whole sequence.[42] Another very basic patch we use for an audio background while the Synalizer and CA phase.[43] This is because it is best to let the modules do as least as possible for easier debugging and reusing them in other projects.

4.2.8. Programming Style

Before we start programming it is very helpful to envision some ideas of an accurate programming style: We want to create small modular patches for reasons mentioned in the previous sections, and encapsulate them in other patches. It is also convenient to use general names for patches of variables, so the modules can be used better in another context. We search for the most simple solutions to complex problems, i.e. we use the object designed for a specific task that demands the fewest number of steps, and let

[42] See Figure A.7 on page f in the appendix.
[43] See Figure A.1 on page c in the appendix.

patches do a limited number of things; we also want to eliminate redundant objects and variables. At least, we try to avoid using complex objects to do simple jobs.

The readability is a very obvious aim for us and also helping others to see what we have done. It is very helpful for larger projects having a style sheet as in this case,[44] to fix all important programming conventions like: descriptions of the patch's functions and features at their top; comments for not self-explicit parts; speaking object names; giving out- and inlets names; grouping together objects with equal functions. It is also helpful when we try to clean up as much as possible, e.g. hiding all unimportant connections in run mode. In this case, however, it would need more rehearsal time as we had to discover a way to shrink the control interface to a simpler GUI.

Consistency in the conventions, places, font, size and layout, or capital letters for custom-made objects throughout the project is mandatory. The comments and patcher schemes should be similar. For example, the left inlet should be reserved to trigger the operation performed by the object. However, some of this project's modular subpatches have a more general style (e.g. no background color), so they can be more easily reused.

The greatest wish of a programmer is to reach a state where the code is foolproof, i.e. it works for all possible situations and accepts any kind of information that a user may enter. To come closer to that aim we limit parameters of number boxes and sliders and provide a clear way to start and stop processes. Here, a reset function is very helpful to stop the whole sequence, bringing it back to an original state as included in the timeline.[45] However, most weak points of a program can be prevented through carefully planning beforehand and testing that plan continuously during realisation.

4.2.9. Hardware Requirements

The hardware we basically need for the installation are: a screen, a video beamer, a DV camera and tripod, a Macintosh computer, an amplifier with minimum two loud speakers, a microphone with stand.

For the technical requirements of the Macintosh computer we have a clear statement from the Cycling '74 product page:[46]

- Mac OS X 10.3 or higher

- 256 MB of RAM

- QuickTime 6.0 or later

- OpenGL 1.5 or later

[44]See Figure A.2 on page d in the appendix.
[45]See Figure A.6 on page e.
[46]Cycling 74' (2006).

- For running Jitter 1.5, Max/MSP 4.5.5 or later is needed

- It's recommended using an OpenGL hardware-accelerated video card, and a multiprocessor

However, it is recommended to provide a slightly better system performance, in order to make sure the content will be presented without disturbing drop outs in sound or video. Of course, the system must be provided with a sound card that offers connections for a microphone and audio playback.

The DV camera has to be a QuickTime compatible device, so it can be addressed directly by Jitter. If it features a *sleeping mode* this should be switched off, so the camera holds the connection to the *jit.grab* object and we don't have to reconnect it manually again.

The video projector should provide a minimum of 800x600 pixels (SVGA), but XGA with 1024x768 pixels results in a better image quality. This also depends on the system performance of the computer. In a smaller darkened room of about 4mx9m a luminous flux between 1000 and 1500 ANSI lumen should be sufficient. For bigger rooms stronger projectors maybe needed. It is desirable to use a preferably calm device, if it stands in the same room with the recording camera, e.g. when projecting through a window into the installation room.

The microphone inside the projection room must be able to clearly pick up the human voice and also should be of a normal size, so the user can recognize it easily and we can put it on a microphone stand. As we are inside a building we can use a condenser microphone preferably with a big membrane (for optical reasons). However, we must note this kind of microphone needs power supply from batteries or phantom power, e.g. from an audio mixer. For longer showing periods it is not acceptable to run the microphone with batteries. In this case the soundcard should provide XLR-phantom power with its input or other power supply should be guaranteed.

For the video statements we can use the microphone included in the DV camera. If the noise of the beamer is very loud we can use an external microphone with cardioid or even hypercardioid pattern instead for lessening the disturbing noise's effect while recording.

The room must be darkened, thus no light changes outside the room interfere with the experience. Microphone cables and others inside the dark room must be covered and fixed to the floor with tape for security reasons.

4.3. Experiences

4.3.1. User Feedback

Unfortunately, the installation had no larger audience before the print of this thesis. Nevertheless, with the feedback of some users we can see which points tend to work well technically or in the intended sense, and which parts could be improved, or even should be changed. However, the average of users mention their interest in the issues the installation raises, and tell that they often think and talk about it even days after their experience. This is a major goal for which the installation was created.

The user interface is one of the most difficult and important parts of an installation. As Masaki Fujihata writes:

> [...] the role of the interface is to visualize the meanings inside the system and to be transparent[...] They should be carefully designed, given that the interface is the surface of interactivity.

Contrarily, one could argue, that interfaces need to 'oscillate between transparency and its opposite'[47] if we want the user to understand her/his relationship to the interface. A longer usability testing time would provide more insights that could lead to improvements.

There are users who feel unable to anticipate the microphone as the switch triggering a sequence cycle. It is questionable if it needs a more obvious hint to make clear that, here, the microphone functions similar to a start button. As we could see at the Ars Electronica Festival 2006, in many cases the installations had instructors or user manuals to offer an explanation or hint as how to use them. However, there are uncountable other ways to provoke a visitor trying to explore the usage of an interface, e.g. through the interface itself.

The Synalizer works well with the microphone and a carefully chosen setting offers various forms of feedback to the human voice. Most users find the combination with the game of life irritating, but this mustn't be judged negatively. However, only a longer period of experimentation would bring a better understanding for the timing and mixture to achieve a more meaningful combination from the content. The design of the Max patches emphatically allows such adaptive modifications. In the end, the video sequence shows three scrolling texts like a news ticker. Most feedback offers the insight that an English scrolling text at such a speed is too difficult to read for a German audience and doesn't support the user even trying to catch some information, as is intended. Hence, adjusting scrolling speed and a text translation into German should be seriously considered.

[47]BOLTER and GROMALA (2003), p.74.

4.3.2. Personal Reflection

Actually, the access to Max's programming concept is very fast and user friendly in comparison to conventional programming languages with abstract coding like C or Java. The documentation and tutorials are a good starting point for learning the basics. Through the interactive help patches, one is invited to learn practically by modifying and using them. With the help of the user forum we received more or less competent responses to rather unusual questions which arose during the realisation phase.

However, practice was seriously troublesome with some of Max's and Jitter's functionality. When trying to run the program on a Windows XP system it was nearly impossible to set up a proper and stable connection from the *jit.qt.grab* object with a DV camera. The developer mentions these problems and refers to a third party developer offering a VDIG component that functions as an interface between QuickTime and the camera. One of them, a commercially available product from Australia for around 40$seems to have vanished from the market at the time needed, and the other option is a freeware tool that supports only a few hardware components listed on the website;[48] it did not work with our available equipment. The better option should be the object using Windows XP native DirectX capabilities, but this seems to be yet a much larger 'building site', and Cycling '74 confesses to this problem in one of the *jit.dx.grab* help patch's subpatch. In our eyes this lack is incommensurate with such a high price for a product that is meant to be platform independent. Here we can see that Jitter is a rather young scion in the family, and Max originally stems from audio processing purposes.

But Max itself gives some strange riddles too. The timeline, for example, sometimes responds to events, and sometimes does not. This had to be altered by deleting and repositioning the marker. Often it is confusing when the markers don't vanish after deleting and we have to move the window in order to clear the track properly. When we started the program on a newer Macintosh computer with Intel processors the whole timeline had to be rearranged in its timing. Another big problem was the *bang* messages in some rather simple situations when using the *tiCmd* or the *jit.qt.movie* object. Sometimes they work as they should do according to the rules, and sometimes they refuse to do so; even more confusing is the fact that they do work properly on another computer. This we could only fix by redesigning the patch and in one case by confining its functionality. All that trouble and malfunctioning left us with a rather unsatisfying feeling and raises doubts if this product at this stage is stable enough for larger interactive video installations.

[48]WinVDIG (2006).

What then is time?
If no one asks me, I know what it is.
If I wish to explain it to him who asks,
I do not know.

Aurelius Augustine

I don't think you have to worry about the future. It isn't
here yet. And now it is gone.

John Cage

5

Conclusion and Future Work

The diploma thesis in hand (or on screen) marks the end of a four year long study
in photo engineering and media technologies at the University of Applied Sciences,
Cologne. The work was nourished from a four month period of research at Dartington
College of Arts in Devon, England, and an interface workshop at the Electrolobby of this
year's Ars Electronica Festival in Austria. The whole work was a very intense and rich
experience that gave profound insights into present media arts practice and interaction
design, and brought back into mind many aspects of the previous studies in Cologne.
For his trustfulness, a big thank you goes to the supervisor Professor Grünvogel who
was supportive and understanding during the whole time.

In the first part of this thesis we tried to give an overview of the recent develop-
ment of digital art, primarily focusing on immersive environments, software art and
installations. We first summarized the latest scientific debate around the quintessential
concepts interactivity and interface design (Section 2.1 on page 5). We could see that
in the past years there have been attempts to unify definitions, each viewing the con-
cepts from different perspectives that are all equally valuable for a better understanding
of the property and action of interactivity, and additionally to form a more cohesive
theoretical framework. At another point we could see that the term interface is also
very debatable and seems to divide interaction designers into two factions. One group
wants the interface to be as transparent and intuitive as possible;[1] the others follow the
opposite strategy wanting the participants to look at the interface rather than through

[1]Although, the extreme would be impossible to reach and not desirable.

it to support their intentions. Both strategies have their own context dependent reasons, although the transparent interface is the far more popular design philosophy in our present western culture, perhaps due to the ubiquitous computer screen designs. An interesting suggestion seems to be, that interfaces should meaningfully oscillate between hiding and revealing themselves according to the users pace of interaction with the system; surely an approach worth further examination in future projects.

Thereafter, equipped with the formal ideas of the key concepts of interactivity, we looked at a selection of representative pieces and their technical background, each one of them standing for a different main form or 'narrative' of present digital art practice (Section 2 on page 5). This shed light on the hybrid and very dynamic nature of the 'Cyber Arts' and the difficulties in arranging them into clear categories. Its playful yet sometimes critical approach to exploring new technologies and their impact on society shows its enormous creative potential; an increasing number of research laboratories are already beginning to profit. We could see how differently interfaces support various meaningful human-computer interaction and some few examples of soft- and hardware technologies that are presently emerging. We have to point out that the range of examples, although carefully chosen, is very limited due to the frame of this work. For deeper insights into the matter we refer to leading research institutions like the Ars Eletronica Center in Linz or the Centre of Art and Media in Karlsruhe.

The following section dealt with the basic concepts and principles behind the programming environment package Max/MSP/Jitter (Section 2 on page 5). We covered Max' main aspects from the origins at IRCAM in Paris over its multimedia-based data processing and interaction capabilities to its options for connecting soft- and hardware interfaces, e.g. via networking technologies. We also covered three main alternative programming concepts that underlie similar philosophies (Section 3.4 on page 31).

The second part of the thesis was a documentation of a concrete interactive installation realised with the graphical programming environment Max/MSP and its extension Jitter. We began with the question, 'which creative concept was leading the process, and why the installation finally achieved its particular appearance for the user?' (Section 4.1 on page 36). It may seem that such an approach has nothing to do with an engineer's profession, but when we look at the experience gained in the past decades, the contrary is the case: especially in interaction design we can't omit the users psyche and cultural background, even as technician or programmer. Otherwise we would still sit in front of screens that try to tell us: 'GENERAL FAILURE READING DISK D:'. Without a doubt, this was necessary in order to try to shape a meaningful interactive piece that catches a *human* user's attention and therefore enhances the quality of interactivity. It makes allowance for the fact that successful interaction design needs to incorporate aspects of the *positioning* of its participants as described in Section 2.1 on page 5. These pre-

ceding considerations were the basis of a clear concept that lead the realisation phase (Section 4.2 on page 40).

The main parts of the program and its functionality were described in the order of their appearance to the participant (Section 4.2 on page 41). Details of important parts of the patches and their technical background, e.g. Max' OpenGl rendering and real-time video processing capabilities were covered. Finally, a summary of user feedback, and of the experience with the work process of programming with Max were given (Section 5 on page 55).

Within the limits of the thesis we couldn not gain far-reaching experience with the installation setting. It would bring valuable knowledge to see how larger groups of users with differing cultural background would react to the system. Analyses of this knowledge could be used for refining the combination of the content, its timing and image quality, the choice of most appropriate technical devices and their initial param-eters. Additionally, a longer experimentation phase would clarify which parts of the patches can be hidden to simplify the appearance to the coordinator of the installation. Interesting ideas for extension include a simple GUI that shows all main parameters in one window making control easier, or the realisation of a more self-explicit interface for starting the sequence cycle.

Finally, to build a stand-alone application, still flexible in its parameters and to the usage of different hardware components, working on both system platforms, would be desirable.

List of Figures

[2] KIOUSIS (2002), p.372.
[3] AEC ARS ELECTRONICA CENTER (2006).
[4] CASSINELLI and ISHIKAWA (2005).

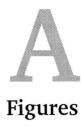

Figures

A.1. Patches

Figure A.1.: Patch for audio playback

Figure A.2.: Stylesheet as programming guideline

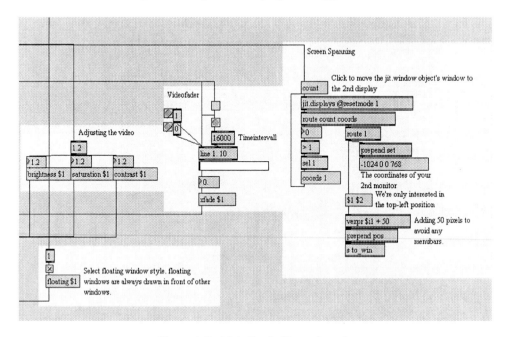

Figure A.3.: Main Patch (Second part)

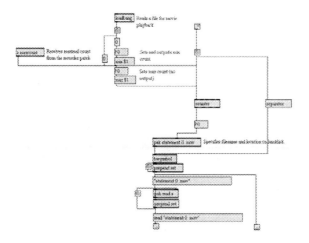

Figure A.4.: Automatical File Reading

Figure A.5.: Timeline Editor Window: Beginning of endsequence

Figure A.6.: Timeline Editor Window: End of timeline with reset sequence

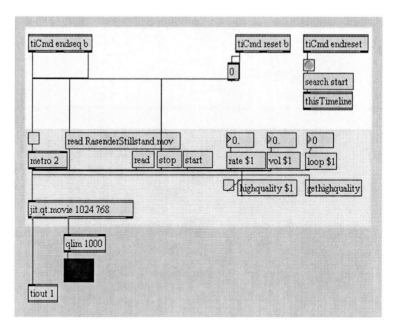

Figure A.7.: Video player for the end sequence

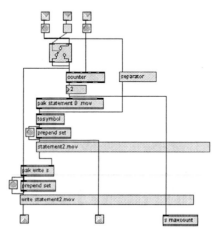

Figure A.8.: Subpatch for automatically naming files

A.2. Sketches

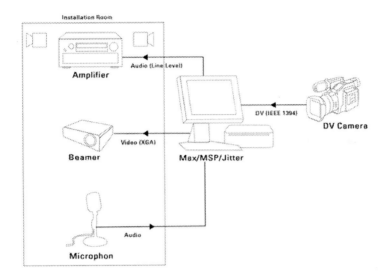

Figure A.9.: Schematic diagram of the hardware setup

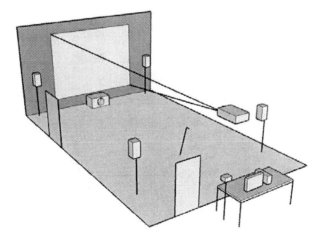

Figure A.10.: Sketch of the installation (Isometric)

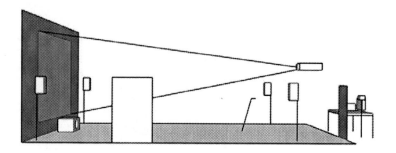

Figure A.11.: Sketch of the installation (Left)

Figure A.12.: Sketch of the installation (Top)

Bibliography

[1] **1394 Trade Association:** ⟨Available at: http://www.1394ta.org/index. html⟩ – Accessed: 9 September 2006.

[2] **Aarseth, Espen:** *We all want to change the world: the ideology of innovation in digital media.* Cambridge, MA, USA: MIT Press, 2003, pp. 415–439, ISBN 0–262–12256–1. 5

[3] **AEC Ars Electronica Center:** *Honorary Mention– Isadora / Future of Memory Improvisation.* ⟨Available at: http://www.aec.at/en/archives/ prix_archive/prix_projekt.asp?iProjectID=12915&iCategoryID= 2547⟩ – Accessed: 17 May 2006. 33

[4] **Idem:** *Ars Electronica Archive.* ⟨Available at: http://www.aec.at/en/ archives/picture_ausgabe_03_new.asp?iAreaID=0&showAreaID= 2&iImageID=22052⟩ – Accessed: 01 October 2006. a

[5] **Apple Computer:** *QuickTime Technologies.* ⟨Available at: http://www.apple. com/quicktime/technologies/⟩ – Accessed: 9 September 2006. 41

[6] **Arduino:** *Project Page.* ⟨Available at: http://www.arduino.cc/⟩ – Accessed: 09 September 2006. 29

[7] **Ars Electronica Futurelab:** *ARSBOX.* ⟨Available at: http://futurelab.aec. at/arsbox/index.htm⟩ – Accessed: 26 April 2006. 13

[8] **Ascott, Roy; Shanken, Edward A., editor:** *Telematic embrace: Visionary theories of art, technology and consciousness.* University of California Press, 2003.

[9] **Barragn, Hernando:** *Wiring.* ⟨Available at: http://wiring.org.co/index. html⟩ – Accessed: 11 October 2006. 29

[10] **Benchun, Ben:** *flosc : Flash OpenSound Control.* ⟨Available at: http://www. benchun.net/flosc/⟩ – Accessed: 14 October 2006. 25

[11] **Bernstein, Jeremy and Clayton, Joshua Kit:** *Jitter Tutorial.* ⟨Available at: Availableat:http://www.cycling74.com/twiki/bin/view/ ProductDocumentation/OlderDocumentation⟩ – Accessed: 20 September 2006. 23, 46, 49

[12] **Bolter, Jay D. and Gromala, Diane:** *Windows and Mirrors– Interaction Design, Digital Art, and the Myth of Transparency.* MIT Press, 2003. 7, 53

[13] **Campen, Cretien van:** *Artistic and Psychological Experiments with Synesthesia.* *LEONARDO*, Vol. 32 1999, Nr. Vol. 32, pp. 9–14.

[14] **Cassinelli, Alvaro:** *The KHRONOS PROJECTOR.* ⟨Available at: http://www.k2.t.u-tokyo.ac.jp/members/alvaro/Khronos/⟩ – Accessed: 16 June 2006. 16

[15] **Idem:** *Khronos Projector simplified demos.* ⟨Available at: http://www.k2.t.u-tokyo.ac.jp/members/alvaro/Khronos/Khronos_P5/Khronos_Applets.htm⟩ – Accessed: 17 May 2006. 16

[16] **Idem and Ishikawa, Masatoshi:** *Khronos Projector.* 2005, Emerging Technologies, SIGGRAPH 2005, Los Angeles (2005); Power Point presentation. a

[17] **CNMAT:** ⟨Available at: http://www.opensoundcontrol.org/node/122⟩ – Accessed: 18 October 2006. 25

[18] **Idem:** *Center for New Music and Audio Technologies.* ⟨Available at: http://www.cnmat.berkeley.edu/⟩ – Accessed: 12 October 2006. 25

[19] **Idem:** *OpenSound Control.* ⟨Available at: http://www.cnmat.berkeley.edu/OpenSoundControl/⟩ – Accessed: 12 October 2006. 25

[20] **Idem:** *OpenSound Control in SuperCollider.* ⟨Available at: http://www.cnmat.berkeley.edu/OpenSoundControl/SuperCollider/⟩ – Accessed: 14 October 2006. 25

[21] **Costabile, Sue:** *A Video Interview with Matt Wright, Musical Systems Designer.* ⟨Available at: http://www.cycling74.com/story/2005/9/28/125618/985⟩ – Accessed: 10 April 2006. 27

[22] **Couturier, Jean-Michel:** ⟨Available at: http://www.jmcouturier.com/⟩ – Accessed: 01 October 2006. 27

[23] **Cuartielles, David:** *Electrolobby.org.* ⟨Available at: http://www.electrolobby.org/⟩ – Accessed: 10 August 2006.

[24] **Cycling 74':** ⟨Available at: http://www.cycling74.com/products/jitter⟩ – Accessed: 10 April 2006. 18, 51

[25] **Danks, Mark:** *GEM.* ⟨Available at: http://www.danks.org/mark/Main/GEM.html⟩ – Accessed: 14 Mai 2006. 31

[26] **Dermietzel, Markus:** *gro.* ⟨Available at: http://www.gro.de/index.php?visualization02intr_en⟩ – Accessed: 20 September 2006. 45

[27] **Idem:** *Synaesthetic Sound Synthesis.* ⟨Available at: http://www.gro.de/index.php?visualization02down_en⟩ – Accessed: 20 September 2006. 45, 46

[28] **Eckel, Gerhard:** *Gerhard Eckel.* ⟨Available at: `http://viswiz.imk. fraunhofer.de/\unhbox\voidb@x\penalty\@M\eckel/`⟩ – Accessed: 10 April 2006.

[29] **FreeFrame:** *Open-source cross-platform real-time video effects plugin system.* ⟨Available at: `http://freeframe.sourceforge.net/`⟩ – Accessed: 14 September 2006. 33

[30] **Fujihata, Masaki; Stocker, Gerfried and Schöpf, Christine, editors:** *On Interactivity.* Springer-Verlag Wien/New York, 2001, pp. 316–319. 7

[31] **Fujihata, Masaki et al.; Leopoldseder, Hannes, Schöpf, Christine and Stocker, Gerfried, editors:** Chap. Interactive Art Today: Between Tradition and Innovation In *PRIX ARS ELECTRONICA- CyberArts 2006.* Hatje Cantz, 2006, pp. 102–143. 10, 16

[32] **Gardner, Martin:** *MATHEMATICAL GAMES– The fantastic combinations of John Conway's new solitaire game "life".* Scientific American, Vol. 223 October 1970, pp. 120–123. 48

[33] **Gergen, Kenneth:** *The Saturated Self. Dilemmas of Identity in Contemporary Life.* New york: Basic Books, 2000. 38

[34] **Giannetti, Claudia:** *Media Art Net– Aesthetics of the Digital.* ⟨Available at: `http://medienkunstnetz.de/themes/aesthetics_of_the_digital/ aesthetics_and_communicative\%20Context/scroll/`⟩ – Accessed: 27 June 2006. 8, 9

[35] **Goethe, Johann Wolfgang von; Cage, John, editor:** *Goethe on Art. Introduction to the 'Propyläean'.* London: Scolar Press, 1980.

[36] **Haahr, Mads:** *The Dreams of an Accelerated Culture.* Crossings: eJournal of Art and Technology, Volume 1, 2001, Nr. Issue 1, pp. 1–10 ⟨Available at: `http:// crossings.tcd.ie/issues/1.1/Haahr/`⟩. 36, 39

[37] **Heidegger, Martin:** *Sein und Zeit.* 18th edition. Niemeyer Verlag Tübingen, 1927. 37

[38] **Hempel, Leon and Metelmann, Jörg, editors:** *Bild - Raum - Kontrolle; Videoüberwachung als Zeichen gesellschaftlichen Wandels.* Suhrkamp Verlag, Frankfurt am Main, 2005.

[39] **Ishikawa Nami Komuro laboratory:** *Vision Chip.* ⟨Available at: `http://www. k2.t.u-tokyo.ac.jp/vision/VisionChip-e.html`⟩ – Accessed: 17 May 2006. 16

[40] **JazzMutant:** *Lemur.* ⟨Available at: `http://www.jazzmutant.com/lemur_ overview.php`⟩ – Accessed: 06 October 2006. 27

[41] **Jehan, Tristan:** *Max/MSP.* ⟨Available at: http://web.media.mit.edu/ \unhbox\voidb@x\penalty\@M\tristan/⟩ – Accessed: 20 September 2006. 46

[42] **Kiousis, Spiro:** *Interactivity: a concept explication. New Media Society,* Vol. 4 September 2002, Nr. 3, pp. 355–383 ⟨Available at: http://nms.sagepub.com/ cgi/content/abstract/4/3/355⟩. 6, 12, a

[43] **Krämer, Sybille, editor:** *Medien Computer Realität; Wirklichkeitsvorstellungen und Neue Medien.* Suhrkamp Verlag, Frankfurt am Main, 1998.

[44] **Kunst Universität Linz:** *Interface Culture.* ⟨Available at: http://www.ufg.ac. at/portal/EN/institut_fuer_medien/masterstudium_interface_ culture/603.html⟩ – Accessed: 17 September 2006. 14

[45] **La Fata, Topher:** *Max/MSP- Writing Max Externals in Java.* ⟨Available at: http://pcm.peabody.jhu.edu/\unhbox\voidb@x\penalty\@M\ wright/stdmp/docs/WritingMaxExternalsInJava.pdf⟩ – Accessed: 30 March 2006. 24

[46] **La kitchen:** *Kroonde Gamma.* ⟨Available at: http://www.la-kitchen.fr/ kitchenlab/kroonde-en.html⟩ – Accessed: 8 August 2006. 30

[47] **Lauer, Robert:** *Temporal Man. The Meaning and Uses of Social Time.* New York: Praeger, 1981.

[48] **Lieberman, Zachary:** *drawn.* ⟨Available at: http://thesystemis.com/ drawnInstallation/⟩ – Accessed: 11 August 2006. 16

[49] **Idem:** *OpenFrameWorks.* ⟨Available at: http://www.openframeworks.cc⟩ – Accessed: 03 September 2006. 16

[50] **Make:** *MAKE Controller Kit.* ⟨Available at: http://www.makingthings.com/ makecontrollerkit/index.htm⟩ – Accessed: 18 October 2006. 30

[51] **MAT:** *Illposed Software Java OSC.* ⟨Available at: http://www.mat.ucsb.edu/ \%7Ec.ramakr/illposed/javaosc.html⟩ – Accessed: 14 October 2006. 25

[52] **McLuhan, Marshall:** *Understanding Media.* Routledge, London/New York, 1964. 7

[53] **Meredieu, Florence de, editor:** *Digital and video art.* Chambers Harrap Publishers Ltd 2005, 2005.

[54] **MESO:** ⟨Available at: http://www.meso.net/main.php⟩ – Accessed: 02 September 06.

[55] **Mignonneau, Laurent and Sommerer, Christa:** *Creating Artificial Life for Interactive Art and Entertainment. LEONARDO,* Vol. 34 2001, Nr. No. 4, pp. 303307.

[56] **MIT Media Lab:** ⟨Available at: http://www.media.mit.edu/people/bio_ maeda.html⟩ – Accessed: 12 August 2006. 35

[57] **Müller, Edward:** *V-Joy*. ⟨Available at: http://www.digital.udk-berlin. de/de/projects/winter0405/grundstudium/hauptp04_05/vjoy. html⟩ – Accessed: 12 October 2006. 27

[58] **OpenSoundControl:** *Project Page.* ⟨Available at: http://www. opensoundcontrol.org/⟩ – Accessed: 12 October 2006.

[59] **Paul, Christiane:** *Digital art.* New York : Thames & Hudson, 2003. 7

[60] **Paul, Christine:** *Renderings of Digital Art. Leonardo*, Vol. 35 2002, pp. 471–484. 10

[61] **Processing:** *Project Page.* ⟨Available at: http://processing.org/⟩ – Accessed: 10 October 2006. 16, 29

[62] **Rafaeli, S.; Hawkins, J.M. Wieman and Pingree, S., editors:** Chap. Interactivity: From New Media to Communication, In *Advancing Communication Science: Merging Mass and Interpersonal Processes.* Newbury Park, CA: Sage, 1988, pp. 11034.

[63] **Richards, Russell:** *Users, interactivity and generation. New Media & Society*, Vol. 8 2006, pp. 531–550. 6, 7

[64] **Roda, Claudia and Thomas, Julie; Ghaoui, C., editor:** Chap. Digital Interactivity: various points of view In *Encyclopaedia of HCI.* IDEA Group, 2005.

[65] **Rokeby, David:** *Transforming Mirrors : Subjectivity and Control in Interactive Media.* ⟨Available at: http://homepage.mac.com/davidrokeby/mirrors. html⟩ – Accessed: 1 May 2006. 36

[66] **Idem:** Chap. The Construction of Experience: Interface as Content In *Digital Illusion: Entertaining the Future with High Technology.* ACM Press, New York, 1998, pp. 27–47. 7

[67] **Idem:** *Media Installation Artist.* ⟨Available at: http://homepage.mac.com/ davidrokeby/home.html⟩ – Accessed: 10 September 2006. 28

[68] **Idem:** *softVNS 2 real time video processing and tracking software for Max.* ⟨Available at: http://homepage.mac.com/davidrokeby/softvnshome. html⟩ – Accessed: 11 October 2006. 28

[69] **Rosa, Hartmut:** *Beschleunigung. Die Veränderung der Zeitstrukturen in der Moderne.* Suhrkamp, 2005. 36, 37, 38

[70] **Rumori, Martin:** *Grenzenlose Freiheit- interactive sound installation.* ⟨Available at: http://www.grenzenlosefreiheit.de/freiheit.php? target=home&lang=en⟩ – Accessed: 05 April 2006. 13, 14, 15

[71] **Schöpf, Christine and Stocker, Gerfried, editors:** *Ars Electronica 2006 Catalog; SIMPLICITY- the art of complexity.* Hatje Cantz Verlag, 2006. 29

[72] **Sester, Marie:** *ACCESS Project.* ⟨Available at: http://www.accessproject. net/index.html⟩ – Accessed: 15 July 2006. 10

[73] **Idem:** *Marie Sester Projects.* ⟨Available at: http://www.sester.net/index_ enhanced.html⟩ – Accessed: 03 April 2006. 10, 11

[74] **SGI:** *OpenGL– The Industry's Foundation for High Performance Graphic.* ⟨Available at: http://www.opengl.org/⟩ – Accessed: 26 April 2006.

[75] **Stocker, Gerfried and Schöpf, Christine, editors:** *TAKEOVER– whos doing the art of tomorrow.* Springer-Verlag Wien/New York, 2001. 36

[76] **Idem**CODE– *The Language of our Time.* Hatje Cantz Verlag, 2003. 16

[77] **WACOM:** *Intuos3.* ⟨Available at: http://www.wacom.eu/uk/products/ intuos/index.asp⟩ – Accessed: 12 July 2006. 27

[78] **Weibel, Peter; Christa Sommerer, Laurent Mignonneau, editor:** Chap. The Unreasonable Effectiveness of the Methodological Convergence of Art and Science In *Art @ Science.* Springer-Verlag, Vienna/New York, 1997, pp. 167–180. 8, 35

[79] **Wenger, Lisa:** *Canadian Database on Time Pressure, Stress and Health.* ⟨Available at: http://lifestress.uwaterloo.ca/⟩ – Accessed: 19 Mai 2006. 37

[80] **Whitelaw, Mitchell:** *Metacreation. Art and Artificial Life.* MIT Press, 2004. 15

[81] **Winkler, Todd:** *Composing Interactive Music: : Techniques and Ideas Using Max.* MIT Press, 1998.

[82] **WinVDIG:** *List of WinVDIG tested hardware.* ⟨Available at: http://www.vdig. com/WinVDIG/compatability.html⟩ – Accessed: 10 September 2006. 54

[83] **zmlnig, IOhannes m:** *Pure Data.* ⟨Available at: http://pd.iem.at/⟩ – Accessed: 01 May 2006. 31

Printed in the United States
129220LV00004B/49/A

9 783836 412988